THE MUSEUM OF MODERN ART, NEW YORK

PAUL KLEE

STATEMENTS BY *the artist*

ARTICLES BY *Alfred H. Barr, Jr.*
Julia and Lyonel Feininger
James Johnson Sweeney

EDITED BY *Margaret Miller*

Acknowledgments

The first edition of this book was prepared in 1941 by the Museum's Department of Circulating Exhibitions as a catalog of the Paul Klee memorial exhibition which was shown at: The Arts Club of Chicago; The City Art Museum of St. Louis; The Portland Art Museum, Portland, Ore.; The San Francisco Museum of Art; Smith College Museum of Art, Northampton, Mass.; The Stendhal Galleries, Los Angeles; Wellesley College, Wellesley, Mass.; The Museum of Modern Art, N. Y.

For the second, revised and enlarged edition the editor wishes to thank the following who have graciously furnished information: Albert C. Barnes, Barnes Foundation, Merion, Pa.; Miss Elmira Bier, Phillips Memorial Gallery, Washington, D. C.; Mrs. Florence C. Berger, Wadsworth Atheneum, Hartford, Conn.; George Heard Hamilton, Yale University Art Gallery; Miss Dorothy Hertage, City Art Museum of St. Louis; Miss Una Johnson, Brooklyn Museum; Daniel Catton Rich and Hugh Edwards, the Art Institute of Chicago; Miss Elizabeth Mongan, National Gallery of Art; Dr. Grace McCann Morley, San Francisco Museum of Art; Miss Ruth S. Magurn, Fogg Museum of Art; J. B. Neumann, and Karl Nierendorf.

For special assistance and counsel the editor is indebted to Alfred H. Barr, Jr., Mr. and Mrs. Lyonel Feininger, Robert Goldwater, James Johnson Sweeney and Curt Valentin.

The translation of extracts from Klee's journal have been reprinted from *Artists on Art*, through the kind permission of the Pantheon Books. The English version of Klee's *Opinions on Creation* is largely the work of Mimi Catlin and Greta Daniels of the Museum staff.

M. M.

Second edition revised.
Copyright 1945 by the Museum of Modern Art, New York. Printed in the U. S. A.

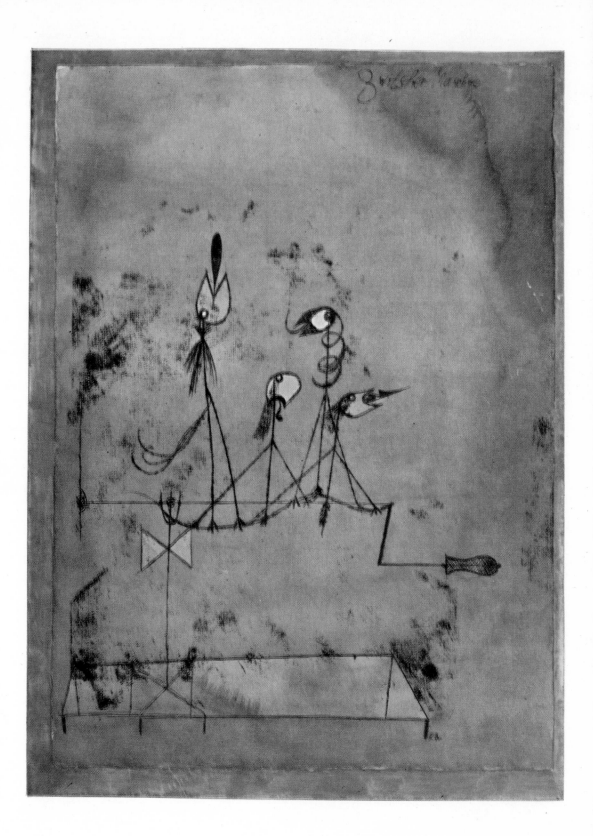

Contents

Paul Klee. 1926.

Introduction

His father a Bavarian, his mother Southern French, Paul Klee was born, with geographical appropriateness, in Switzerland near the town of Berne, in the year 1879. His childhood was passed in an atmosphere of music for his father was a professional musician and conductor of the orchestra in which his son at an early age played the violin. His mother, too, came of a musical family so that for a time he expected to become a musician. However, after much debate, he was sent in 1898 to Munich to study drawing, at first at the Knirr school, and then with Franz Stuck at the Academy. Stuck was an academic painter of bizarre and macabre subjects, at times coarsely banal, but with considerable imaginative power. In 1901 Klee made the orthodox journey to Italy, but quite unorthodoxly he preferred Early Christian art to that of the Quattrocento, Baroque to High Renaissance painting, and the Naples aquarium to the classical antiquities of the Naples Museum.

For the next few years Klee lived with his parents, producing very slowly a remarkable series of etchings, among them *Perseus* (page 9) which he exhibited in Switzerland and Munich. Though he visited Paris he did not at first become aware of the post-impressionist and *fauve* revolutions. He found himself more concerned with drawing and caricature than with painting. Goya's fan-

4

tastic *Caprichos* interested him as did the other-worldly engravings of Blake and Fuseli. Of more recent draftsmen he found Kubin's weird humor, the bizarre pathos of James Ensor, and Redon's visionary lithographs most to his taste. He read the tales of Hoffmann and of Poe, the prose and poetry of Baudelaire. His admirations both in graphic art and literature were clearly fantastic.

He moved to Munich in 1906. In the next four years he came to know through exhibitions van Gogh, then Cézanne, and finally Matisse, who opened the eyes of the young artist to the expressive (as opposed to the descriptive) possibilities of color and to the charm of the apparently artless and naive.

In Munich he became acquainted with three other young painters, Kandinsky, a Russian who had also studied under Stuck, Franz Marc, and August Macke, the last two, both of them men of great promise, lost to German art during the First World War. The four formed the nucleus of the famous group, *Der Blaue Reiter*, which raised the banner of revolt in staid academic Munich, won a considerable success in Berlin and made the word "expressionism" known throughout the world. Marc painted compositions of animals, using brilliant, pure color, a line of great style and a somewhat cubistic technique. Kandinsky's abstract *Improvisations* were among the first to disregard entirely all vestiges of representation. But Klee, while he experimented with abstract design, continued his researches in the realm of fantasy.

In 1912 Klee visited Paris, where he stayed for over a year. Guillaume Apollinaire, Picasso, Delaunay, became his friends. A journey to Tunisia (Kairuan) in 1914 seems to have been equally important in the discovery of himself.

Shortly after the War, the town of Weimar asked the architect Walter Gropius to reorganize the art school. The Bauhaus, as the new school was called, was primarily a technical school devoted to the study of materials and design in architecture, furniture, typography, and other modern industrial arts. As a "spiritual counterpoint" to these technological and utilitarian activities Gropius invited three painters to live at the Bauhaus and give instruction in drawing and painting. They were the Russian Kandinsky, the American Feininger, and the Swiss Klee, three of the most gifted as well as the most adventurous artists at work in Germany.

Klee remained as professor at the Bauhaus from 1920 to 1928. In 1926 the Bauhaus moved to Dessau and in the same year Feininger, Javlensky, Kandinsky, and Klee formed the Blue Four which exhibited throughout Germany and America. Klee also sent paintings to the *Société Anonyme* exhibitions in New York and Brooklyn.

Klee was "claimed" by the surrealist group in Paris but refused to become in any formal sense a member of the movement. His work is, however, perhaps the finest realization of the surrealist ideal of an art which appears to be purely of the imagination, untrammeled by reason or the outer world of empirical experience.

About 1929 Klee left the Bauhaus and accepted a professorship in the Düsseldorf Academy where he taught for three years. In the spring of 1933 came the Nazi revolution which forced all art in Germany to conform to the timid and vulgar prejudices of Adolf Hitler. Klee left Germany in disgust and returned to Berne. In Switzerland he died seven years later, honored throughout the world wherever the human spirit still retained its freedom.

Klee, when one talked with him, seemed the opposite of eccentric, in spite of his amazing art.

When I visited him at Dessau in 1927 he was living in a house designed by Gropius as a *machine à habiter* near the factory-like Bauhaus building. He was a smallish man with penetrating eyes, simple in speech and gently humorous. While one looked over his drawings in his studio one could hear his wife playing a Mozart sonata in the room below. Only in one corner were there significant curiosities, a table littered with shells, a skate's egg, bits of dried moss, a pine cone, a piece of coral, fragments of textiles, a couple of drawings by the children of his neighbor, Feininger. These served to break the logical severity of the Gropius interior and Bauhaus furniture—and perhaps also served as catalytics to Klee's creative activity.

Much has been written in German and French about Klee's art. Indeed few living painters have been the object of so much speculation. For a work by Klee is scarcely subject to methods of criticism which follow ordinary formulae. His pictures cannot be judged as representations of the ordinary visual world. Usually, too, they cannot be judged merely as formal compositions, though some of them are entirely acceptable to the esthetic purist.

Their appeal is primarily to the sentiment, to the subjective imagination. They have been compared, for this reason, to the drawings of young children at an age when they draw spontaneously from intuitive impulses rather than from observation. They have been compared to the fantastic and often truly marvelous drawings of the insane who live in a world of the mind far removed from circumstantial reality. Klee's work sometimes suggests the painting and ornament of primitive peoples, such as: palaeolithic bone carvings, Eskimo drawings and Bushman paintings, the pictographs of the American Indian. Drawings made subconsciously or absentmindedly or while under hypnosis occasionally suggest Klee's devices. In fact, Klee did himself at times make "automatic" drawings with some success. The child, the primitive man, the lunatic, the subconscious mind, all these artistic sources (so recently appreciated by civilized taste) offer valuable analogies to Klee's method.

But there are in Klee's work qualities other than the naive, the artless, and the spontaneous. Frequently the caricaturist which he might have been emerges in drawings which smile slyly at human pretentiousness. Often he seduces the interest by the sheer intricacy and ingenuity of his inventions. At times he charms by his gaiety or makes the flesh creep by creating a spectre fresh from a nightmare.

Of course he has been accused of being a "literary" painter. For the person who still insists on regarding painting as decorative, or as surface texture, or pure, formal composition the accusation is just. But Klee defies the purist and insists, as do Chirico and Picasso, upon the right of the painter to excite the imagination and to consider dreams as well as still life material for their art.

Klee is a master of line which seems negligent but is unusually expressive. *Plant Seeds* (page 43) and *The Holy One* (page 29) are suggested by the most sensitive calligraphy. *Zoo* (page 46) presents no earthly animals but creatures of the mind drawn with the finality of hieroglyphics. Equally interesting to the Klee enthusiast are such humorous graphic contrivances as the *Apparatus for the Magnetic Treatment of Plants* (page 30) and *Twittering Machine* (frontispiece).

Klee's abstract designs have little to do with cubism for they, too, are improvisations rather than abstractions of things seen. *Variations* (page 40) is a title drawn from musical terminology. The "theme" is stated in the center square of the picture and varied in the adjoining squares, the

6

original center plaid becoming simpler and more horizontal nearer the edges of the design. *Hall C. Entrance R. 2* (page 27) and *Pastorale* (page 44) are studies in horizontal banding. *Abstract Trio* (page 34), obviously suggested by music, seems related to the linear abstractions of Miro and Masson.

Klee made a study of masks in theatrical and ethnographic museums, and experimented with their power to startle and bind the imagination. *Actor's Mask* (page 41) reminds one of Melanesian ceremonial masks in its startling, hypnotic effect. Comparable as disquieting apparitions are the large *Mask of Fear* (page 54) and the extraordinary *Cat and Bird* (page 47).

The arrow is a motive which frequently occurs in Klee's compositions. It is used to indicate the movement and direction of forces or thoughts as in the diagrams from Klee's course at the Bauhaus. In *Mixed Weather* (page 49) the arrow sweeps along the earth like a tempest beneath the dripping moon. It is more literally a missile in *Diana* (page 53).

Klee has used a variety of media, all of them handled with remarkable skill and inventiveness. He combines watercolor and ink, oil and gouache, using diverse surfaces including paper, canvas, linen, burlap, silk, tin and compo-board. Like the cubists and surrealists he has made many experiments with textures.

Nothing is more astonishing to the student of Klee than his extraordinary variety. Not even Picasso approaches him in sheer inventiveness. In quality of imagination also he can hold his own with Picasso; but Picasso of course is incomparably more powerful. Picasso's pictures often roar or stamp or pound; Klee's whisper a soliloquy—lyric, intimate, incalculably sensitive.

ALFRED H. BARR, JR.

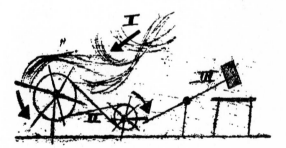

Water Wheel and Trip Hammer.

Active, intermediate and passive factors: I, waterfall (active); II, mill wheels (intermediate); III, trip hammer (passive). Diagram from Klee's *Pedagogical Sketchbook*, written for his students at the Bauhaus.

7

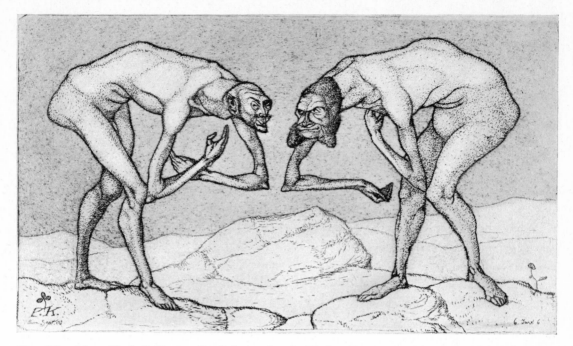

Two Men Meet, Each Believing the Other to be of a Higher Rank. 1903. Etching, 4⅜ x 7⅝". The Museum of Modern Art. Purchase Fund.

Extracts from the Journal of the Artist

Berne, April, 1902

I have to disappoint at first. I am expected to do things a clever fellow could easily fake. But my consolation must be that I am much more handicapped by the sincerity of my intentions than by any lack of talent or ability. I have a feeling that sooner or later I'll arrive at something valid, only I must begin, not with hypotheses, but with specific instances, no matter how minute. If I then succeed in distinguishing a clear structure, I will get more from it than from a lofty imaginary construction. And the typical will automatically follow from a series of examples.

June, 1902

It is a great handicap and a great necessity to have to start with the smallest. I want to be as though newborn, knowing nothing absolutely about Europe; ignoring poets and fashions, to be almost primitive. Then I want to do something very modest; to work out by myself a tiny, formal motif, one that my pencil will be able to hold without any technique. One favorable moment is enough. The little thing is easily and concisely set down. It's already done! It is a tiny but real affair, and some day, through the repetition of such small but original deeds, there will come one work upon which I can really build.

The naked body is an altogether suitable object. In art classes I have gradually learned something of it from every angle. But now I will no longer project some plan of it, but will proceed so

8

that all its essentials, even those hidden by optical perspective, will appear upon the paper. And thus a little uncontested personal property has already been discovered, a style has been created.

December, 1903

When, in Italy, I learned to understand architectural monuments I had to chalk up at once a remarkable advance in knowledge. Though they serve a practical purpose, the principles of art are more clearly expressed in them than in other works of art. Their easily recognized structure, their exact organism make possible a more fundamental education than all the "head-nude and composition studies." Even the dullest will understand that the obvious commensurability of parts to each other and to the whole corresponds to the hidden numerical proportions that exist in other artificial and natural organisms. It is clear that these figures are not cold and dead, but full of the breath of life; and the importance of measurement as an aid to study and creation becomes evident.

The organic richness of nature, because of its never ending complication, is more extensive than finally productive. But the initial helplessness of the student when confronted with it is easily explicable, because at first he sees only its outer branches and has not yet reached the trunk or root. It is not yet evident to him, as it is to the knowing, that the smallest leaf contains precise analogies to the fundamental law of the whole.

Perseus, the Triumph of Wit over Suffering. 1904. Etching, 5 x 5¾". Private collection.

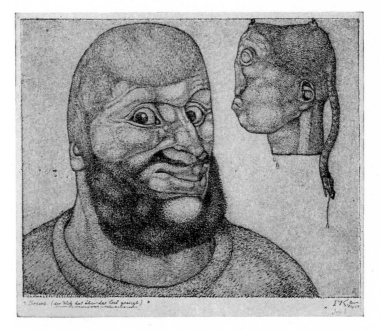

This new Perseus has done away with the lugubrious monster, Suffering, by beheading it. The action is depicted physiognomically in the features of Perseus whose face enacts the deed. A laugh is mingled with the deep lines of pain and finally gains the upperhand. It reduces to absurdity the unmixed suffering of the Gorgon's Head, added at the side. That face is without nobility—the skull shorn of its serpentine adornment except for one ludicrous remnant. December, 1904.

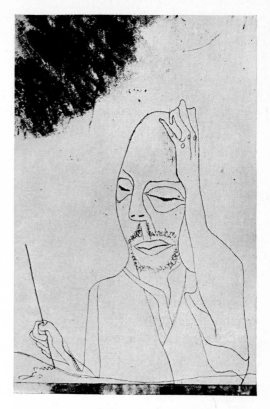

Self-portrait. 1919. Drawing

Opinions on Creation

I

Art does not render the visible but renders visible. The nature of graphic art leads rightly to abstraction. The shadowy and fabulous quality of the imaginary is presumed, and at the same time expresses itself with great precision. The purer the graphic work, that is, the greater the emphasis on the formal elements upon which graphic representation is based, the more defective it is for the realistic representation of visible things.

The formal elements of graphic art are: points, linear, planar, and spatial energies. A simple planar element is, for example, the energy produced by the broad unmodulated stroke of a thick crayon. An example of a spatial element is a moist, vaporous spot of varying intensity made by a full brush.

II

Let us develop, let us make on the basis of a topographic plan, a little journey into the land of greater insight. The dead point must be overcome with the first act of movement (line). After a

The following text is a partial translation of *Schöpferische Konfession* (bibl. 3), a statement by Klee published in 1919.

short time, stop to get your breath (broken line, articulated by repeated stops). A look back to see how far we have already come (counter-movement). In your mind consider the road from here to there (bundle of lines). A stream wishes to hinder us; we use a boat (wave movement). Further on there would have been a bridge (series of curves).

On the other side we find someone of like mind who also wishes to go where greater insight is to be found. At first a joyful agreement (convergence), but gradually all kinds of differences arise (independent direction of two lines). A certain excitement on both sides (expression, dynamics and spirit of the line). We cross an unploughed field (lines crossing a plane), then thick woods. He goes astray, searches and once even goes through the classic movements of the meander.

I, too, am not entirely cool; over new river-land lies fog (space element). Soon it becomes clearer. Basket-makers return home with their wagons (the wheel). With them a child with gay curls (cork-screw movement). Later it becomes sultry and dark (space element). Lightning on the horizon (zigzag line). Above us there still are stars (field of points). Soon we reach our night's lodgings. Before falling asleep many things come back to the mind, for such a little journey leaves strong impressions:

The most various lines. Spots. Dabs. Smooth planes. Dotted planes, lined planes. Wave movement. Impeded, articulated movement. Counter-movement. Plaited, woven. Brick-laid, fish scaled. Monophonic. Polyphonic. Fading, strengthening line (dynamic). The happy symmetry of the first stretch, then the inhibitions, the nerves. Concealed tremors, a cajoling, hopeful breeze. Before the thunderstorm the attack of the gadflies! The fury, the murder.

The good thing as a clue, even through thicket and twilight. The lightning reminded us of that fever curve. Of a sick child once.

III

I have enumerated the elements of graphic representation which should belong to the visual work [points, linear, planar and spatial energies]. This should not be interpreted to mean that a work must consist of such elements only. The elements must produce forms, but without the sacrifice of their own identities. They should preserve themselves.

Usually a combination of several primary elements is necessary to represent forms, objects or other things of secondary rank. Planes by means of interrelated lines (e.g. the path of moving waterbugs), or a spatial organization through three-dimensional energies (fish swimming around in all directions).

Through such enrichment of the formal symphony the possibilities of variation grow infinite and with them the possibilities for expressing ideas. . . .

IV

Motion underlies all stages of becoming. In Lessing's *Laocoön*, on which we wasted so many of our youthful attempts at thinking, a great deal of fuss is made over the difference between temporal and spatial art. Upon closer examination we find that the difference is only an academic delusion, for space itself is a temporal notion.

When a point moves and becomes a line, it requires time. Also when a line becomes a plane.

11

The same is true of the movement of planes into spaces. Does a picture come into being all at once? No, it is constructed piece by piece, just like a house.

And does the spectator take in the work all at once? Often, unfortunately. Didn't Feuerbach say: "In order to understand a picture one needs a chair"? . . . Therefore: time.

Character: movement. Only the dead point is timeless. In the universe, too, movement is taken for granted. Stillness on earth is an accidental stopping of matter. It would be a deception to consider it primary.

The genesis, or process, of writing is a very good image of movement. The work of art, too, is experienced primarily as a process of formation, never as a product.

A certain fire, coming to life, leaps up, runs through the hand, courses onto the paper, and flies back as a spark where it came from, thus completing the circle: back into the eye and on again.

Likewise the activity of the spectator is a temporal one. He brings each part of the picture into his field of vision, and in order to see another he must leave the one just seen. Once he stops and goes away, like the artist. If he considers it worth dwelling on he comes back, like the artist.

Paths are established in the work of art for the eyes of the spectator to follow. . . . Pictorial art springs from movement, is itself fixed movement and is perceived through movement (eye muscles).

<p style="text-align:center">V</p>

We used to represent things visible on earth which we enjoyed seeing or would have liked to see. Now we reveal the reality of visible things, and thereby express the belief that visible reality is merely an isolated phenomenon latently outnumbered by other realities. Things take on a broader and more varied meaning, often in seeming contradiction to the rational experience of yesterday. There is a tendency to stress the essential in the random.

By including the notion of good and evil a moral sphere is created. The evil must not be the triumphant or confounding enemy, but a constructive force, that is, a co-factor in creation and development. The simultaneous presence of the masculine (evil, stirring, passionate) and the feminine (good, growing, calm) produces a state of ethical stability.

Corresponding to this state is the simultaneous unification of forms, movement and counter-movement, or, more naively expressed, the unification of contrasting elements (e.g. Delaunay's use of contrasts of divided color). Each force requires an opposing force to achieve a stable, self-contained state within the picture. In the end a formal cosmos will be created out of purely abstract elements of form quite independent of their configurations as objects, beings, or abstract things like letters or numbers. This formal cosmos, itself an expression of religious feelings, resembles the Creation so closely that only a breath is needed to bring it to life.

<p style="text-align:center">VI</p>

Here are a few examples:

Imagine a man of antiquity sailing a boat, fully enjoying and appreciating the ingenious comfort of the accommodations. The ancients would represent the subject accordingly.

And now the experiences of the modern man striding across the deck of a steamer: 1. his own

movement, 2. the course of the steamer,which could be contrary to his own, 3. the direction of the movement and the speed of the stream, 4. the rotation of the earth, 5. its orbit, 6. the orbits of the moon and stars around it.

The result: a complex of movements within the universe with the man on the steamer as the center.

An apple tree in bloom, its roots, the rising sap, its trunk, the cross-section with the annual rings, the blossom, its structure, its sexual functions, the fruit, the core with its seeds.

A complex of stages of growth.

A sleeping person, the circulation of the blood, the measured breathing of the lungs, the delicate function of the kidneys and a head full of dreams related to the powers of fate.

A complex of functions unified in repose.

VII

Art is a likeness of the Creation. Occasionally, it is an example, just as the terrestrial may exemplify the cosmic.

The release of the graphic elements, their grouping into complex subdivisions, the dissection of the object into different sides and its reconstruction into a whole, the pictorial polyphony, the achievement of balance through an equilibrium of movement—all these are advanced problems of form, decisive for formal knowledge, but not yet art in the highest sense. In the highest sense, an ultimate mystery lies behind the ambiguity which the light of the intellect fails miserably to penetrate.

Yet one can to a certain extent speak reasonably of the salutary effect which art exerts through fantasy and symbols. Fantasy, kindled by instinct-born excitements, creates illusory conditions which can rouse or stimulate us more than familiar, natural, or supernatural ones. Symbols reassure the mind that we need not depend exclusively upon mundane experience with all its possible enhancements. Ethical seriousness rules, along with hobgoblin laughter at doctors and priests.

In the long run enhanced reality offers no solution.

Art plays an unwitting game with ultimate things, yet achieves them nevertheless. . . .

PAUL KLEE

13

Waterplant Scripts. 1924. Watercolor, 9½ x 11½″. Collection Mr. and Mrs. Lyonel Feininger.

Recollections of Paul Klee

No attempt is made here to speak of Paul Klee's work, which is well known and accessible in collections of museums and galleries to every enthusiast.

Knowing the work before the man, we admired the small drawings and paintings of the early period, those runic scratchings on copper plates, hieroglyphs on silk and canvas of figures and buildings, animals and flowers which created a microcosmic world, charming in a strange and unheard-of way. Our first thought was that the man who drew these lines must be a musician besides being a draftsman. We guessed that his instrument was either the flute or the violin; the latter proved to be right. In fact Klee the painter is unthinkable without Klee the musician. Dreamer and visionary, Klee was short and somewhat sturdy, yet fine boned and of delicate physique. The overwhelming impression we got of Klee, when we first met him at the Bauhaus in 1922, was of his eyes. They were brown, wide open, set extremely far apart beneath a broad forehead, they seemed to look through and past one. His jaw bones were rather large, but his mouth

was of the most delicate sensitiveness. A man whose wisdom was profound, and whose knowledge in many fields was amazing. Seemingly ageless, and yet to whom, as to an attentive child, all experiences of the eye and of the ear, of taste and touch, were ever new. Ripe, because his reaction to experiences was resolved into terms of creative incitement, mastered and controlled by his supreme intellect. No outburst broke his calm; his emotions found their outlet in his work, in utter creative silence, and in his interpretations on the instrument he mastered. Never was there the least suggestion of a pose, nor yet of exuberance. He was a supremely good listener. His habitual attitude always seemed to be one of self-communion, of "inner" listening. But when asked to express an opinion, or to deliver a judgment, his answers were fraught with the power of conviction, given with impersonal objectivity, in quiet tones, and the listener was placed under the spell of his personality.

Our memory of Klee in his studio—in the midst of seeming, though carefully ordered, confusion, for he was meticulous in his habits—was of the man himself with his never extinguished pipe, surrounded by a number of easels, each carrying one of those miraculous creations, his paintings, growing into completion slowly and by stages. His method of working can really be compared to the organic development of a plant. There was something akin to magic in the process. For hours he would sit quietly in a corner smoking, apparently not occupied at all—but full of inner watching. Then he would rise and quietly, with unerring sureness, he would add a touch of color here, draw a line or spread a tone there, thus attaining his vision with infallible logic in an almost subconscious way.

Klee loved to collect about him small objects of beauty, in themselves of no importance, such as wings of butterflies, shells, colored stones, strangely formed roots, mosses and other growths. These he brought home from his lonely wanderings about the countryside. Besides contributing to his recognition of structure and harmony of color, these objects contained a deeper meaning for him. Klee once said that he felt his innermost self related to all things under, on and above this earth. Other objects in his studio, products of his spare moments, were contraptions pieced together of flimsy materials such as gauze, wire and bits of wood, some capable of being moved by draughts of air, others manipulated by a tiny crank—ships of weird design, animals, marionettes and masks, which he made for a Punch and Judy theatre for Felix, his son.

One never could pass Klee's house in the evening without hearing the sounds of music. Klee practising on his violin, or playing with Frau Klee at the piano, or with some friends in a trio or quartet. His performance on the violin was spiritual to a high degree, with perfect technique. Music was a fundamental necessity to Klee. Although he had been trained in the classical tradition and his deepest love belonged to Bach and Mozart, later composers such as Ravel, César Franck, Stravinsky, Schoenberg and Hindemith were not excluded. He strove to penetrate into every realm of musical sound and wherever a new aspect of musical expression opened for him, he willingly followed with study and rendering. His acceptance of music might be said to be universal.

If one begins to recall the years passed in close association with Klee, the wealth and profusion of memories becomes too great and overwhelming, hundreds of details contribute to build up the human picture of this most unusual man and artist.

JULIA AND LYONEL FEININGER

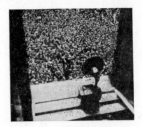

Photograph from a magazine of a loudspeaker addressing a crowd.

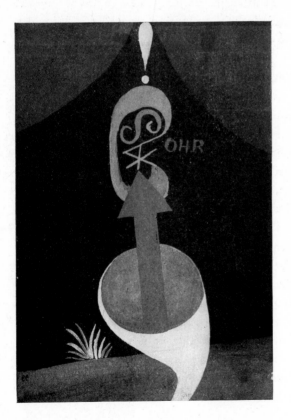

Klee's method of invention ranges from automatic transcription of subconscious prompting to the most deliberate manipulation of form and image. This variation on a magazine photograph, a commissioned work, is one of the simplest and clearest examples of Klee's mode of transposing both visual and invisible experience into pictorial signs and symbols: sound from the loudspeaker appears as an arrow, the crowd as a collective ear, excitement as an exclamation point.

The picture is one of several variations by Bauhaus artists on the same theme, made at the instigation of Moholy-Nagy to be presented to Walter Gropius in a birthday portfolio.

Variation. 1924. Tempera. Collection Walter Gropius.

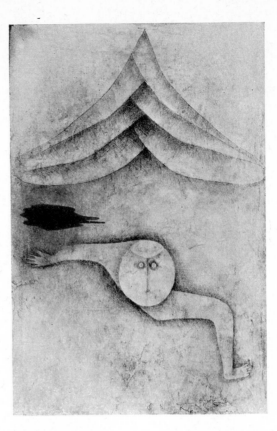

Refuge. 1930. Oil on canvas. Collection Mme. Galka E. Scheyer.

Description of the technique of *The Refuge* inscribed by Klee on the back of the picture.

TECHNIQUE

1 to 5-ground
1, Cardboard,
2, white oil japan color,
 while 2 still tacky:
3, gauze and gesso,
4, redbrown watercolor as an undertone,
5, tempera (Neisch*) zincwhite with addition of glue.
6, Fine drawing and hatchings with watercolor,
7, lightly protected with oil painting varnish, (thinned with turpentine)
8, heightened in parts with zincwhite oil color,
9, coated with grayish-blue oil color, lightly touched over with madder lake oil color.

* trade name of a maker of tempera colors

Though Klee used many different methods of painting, this deceptively simple picture is typical of his technical inventiveness and unorthodox combination of mediums.

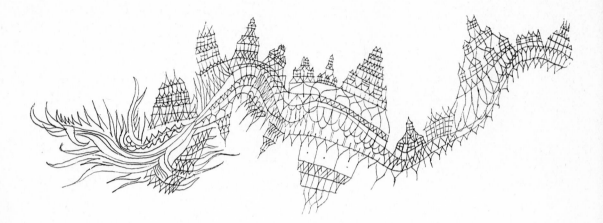

Flood Swamps Cities. 1927. Pen and ink, 10½ x 12″. Reproduced from bibl. 41.

The Place of Paul Klee

In an age that blasted privacy Paul Klee built a small but exquisite shrine to intimacy.

Klee did not belong to the tradition of the great decorators. Though he derived from the German expressionist school that stemmed out of van Gogh and Munch, he was a designer in feathers rather than in flame. In an age that felt "it was necessary to shake an adult to get a reaction out of him," Klee lived fully in elaborating nuances and in capturing fancies. He was not a painter whose work speaks to us from a distance. Klee was fundamentally a cabinet artist who should be read and re-read, in a manner of speaking, on the knee. The subtle complexity of his texture justifies it. He spoke in a mixed tongue of representational and technical phantasy. These were fused by a remarkably untrammeled sensibility. The result was a curious pictorial poetry all his own. And in this character of so much of Klee's work we often feel a closer affinity with Oriental art than with that of the Occident.

Yet if Klee did not belong to the tradition of the great Western decorators, he was the product

18

of a tradition that has deeply marked our times. Klee was born in 1879. Consequently his early impressionable years fell within the nineties—in Central Europe the decade of Munch and Hodler, of van de Velde and Obrist, and particularly of the *art nouveau-Jugendstil* movement. The keynote of the painting of this period was a stress on the basic linear pattern of an expression. Behind it lay the discovery of the Japanese print in the middle of the nineteenth century and, more recently, the adaptation of the Japanese print's broad, running contour-lines by Gauguin, van Gogh and their synthetist followers. Out of it came a new recognition of the immediacy and intimacy with which the emotions speak through the hand when it is not too closely controlled by the conscious, reasoning mind.

This was the door that opened into the art of the twentieth century. In Western painting, especially since the Renaissance, design, planning, coordination of the parts with the whole had commonly taken precedence over our desire for variety, multiplicity, chance and the unforeseeable. The East had always recognized the wealth of obscure nervous and organic impulses that a free manual, or "calligraphic" style contributed toward enriching our expression's sensibility. With the liberation of the hand we begin to see a new rhythmic ordering of European pictorial expression that had its base in the organic life of the individual, rather than in the conscious mind. The way was then clear for the *fauves*, the expressionists, the surrealists, and for artists like Picasso, Kandinsky and Miro, in all of whom we recognize a predominant stress on the linear approach.

In Klee's work a period of wide experimentation succeeded his *art nouveau* apprenticeship. During the decade following 1905 we see traces of many influences: Matisse, Kubin, Nolde, the new German interest in children's drawings, Kandinsky, Delaunay and the Paris cubists in general. Finally, about 1917, Klee's early bent began to reassert itself: "phantasy expressed in predominantly linear compositions"—a calligraphic expression sensitive to the most delicate suggestions of the nervous system, responsive to the most subtle unconscious associations. This was the Klee whom the surrealists recognized as a precursor: a precursor in just such expressions of free sensibility as they ambitioned to achieve: an explorer of intimate lyric rhythms, who never felt the need to undertake surrealism's destructive work before concentrating on the problems raised in art by the "discovery" of the unconscious. This was the Klee who was to persevere in scrupulous craftsmanship and yet grow in invention, lightness of touch and richness of texture from those closing years of the last war down to his death in 1940.

Today we are faced by another vast social crisis. We see a world torn between the two great forces, democracy and totalitarianism. Today a planned organization to which all constituent units or elements are subordinated has the apparent advantage of efficiency. But if civilization is to survive, a new balance of interests must be achieved. In art a rational organization of the broader outlines of an expression, alone, is never enough, in spite of the most careful subordination of parts to the whole. In life the inelastic, inorganic, anti-vital, machine-attitude must give way to a system which will allow for the free development of sensibility and intelligence.

Yesterday, in a blind, self-satisfied world, Klee was forced to withdraw into himself to protect the sensibility his art cultivated. Tomorrow will find Klee's work a delicate distillation of those qualities most needed to give life to a renewed art in a renewed world.

JAMES JOHNSON SWEENEY

19

Chronology

1879 Born December 18 near Berne, Switzerland. Father a Bavarian music teacher and conductor. Mother of Southern French stock.

1898 To Munich. Studied drawing at the Knirr school and later at the Academy under Franz Stuck.

1901 To Italy with the sculptor, Hermann Haller.

1902– With parents at Berne. Trips to Paris, Mu-
1906 nich and Berlin. Exhibited first etchings in Switzerland and Munich.

1906 Married a musician and settled in Munich where he lived until 1920.

1907 Birth of son, Felix.

1908– Came to admire the work of van Gogh,
1910 Cézanne and especially Matisse.

1910 First one-man show, exclusively prints, in Zurich, Berne and Basle.

1911 First one-man show in Germany at gallery of H. Thannhauser, Munich. Became friends with Kandinsky and Franz Marc, leaders of *The Blue Riders.*

1912– Exhibited with *The Blue Riders* in Germany.
1913 To Paris. Knew Apollinaire, Picasso, Rousseau and Delaunay. Exhibited.

1914– Kairuan in Tunisia with August Macke.
1915

1916– In the army as a "painter" and other services.
1918

1920 Growing recognition: large retrospective exhibition, Hans Goltz gallery, Munich; two monographs on Klee published; invited by Gropius to become a professor at the Bauhaus at Weimar, together with Kandinsky and Feininger.

1924 First New York one-man exhibition, *Société Anonyme.*

1926 Moved with Bauhaus to Dessau. Formed with Feininger, Javlensky and Kandinsky the group called *The Blue Four* which exhibited in Germany and America. First one-man show in Paris, Galerie Vavin-Raspail.

1928 Visit to Egypt.

1929 Fiftieth birthday exhibitions in many German and Swiss museums.

c.1930 Appointed professor at Düsseldorf Academy.

1930 One-man exhibition, the Museum of Modern Art, New York.

1931 To Sicily.

1933 Left Germany and settled in Berne, Switzerland

1935 Onset of serious illness.

1940 Died June 29 at Muralto-Locarno, Switzerland.

1940– Memorial exhibitions in Switzerland, England
1941 and the United States.

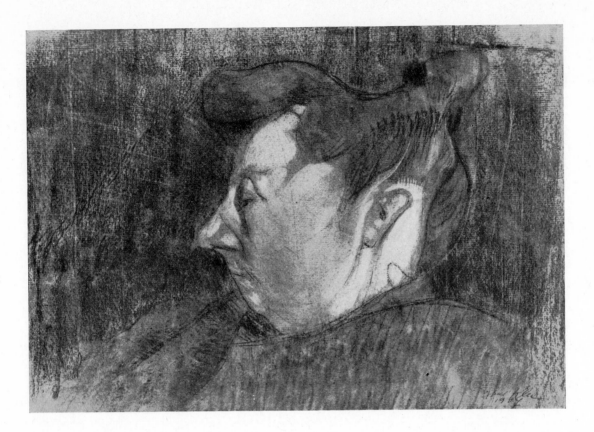

Portrait of a Pregnant Woman. 1907. Charcoal on watercolor wash, 9½ x 13″. The Brooklyn Museum.

Child with Toy. 1908. Pen and ink, 5⅝ x 4″. Collection Edgar Wind.

Seven Girls. 1910. Watercolor, 5⅞ x 4 ⁷⁄₁₆″. Collection Miss Anna Sweeney.

Little World. 1914. Etching, 5⅝ x 3¾″.
The Museum of Modern Art. Purchase
Fund.

Opus 32. 1915. Watercolor, 7 x 5⅜″. Weyhe
Gallery.

opposite: Demon above the Ships. 1916. Watercolor, 9 x 7⅞″. The Museum of Modern Art.
Purchase Fund.

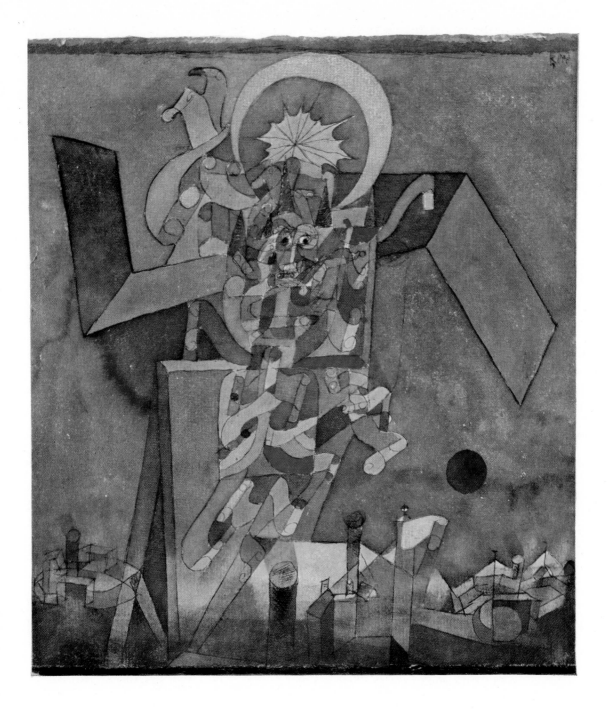

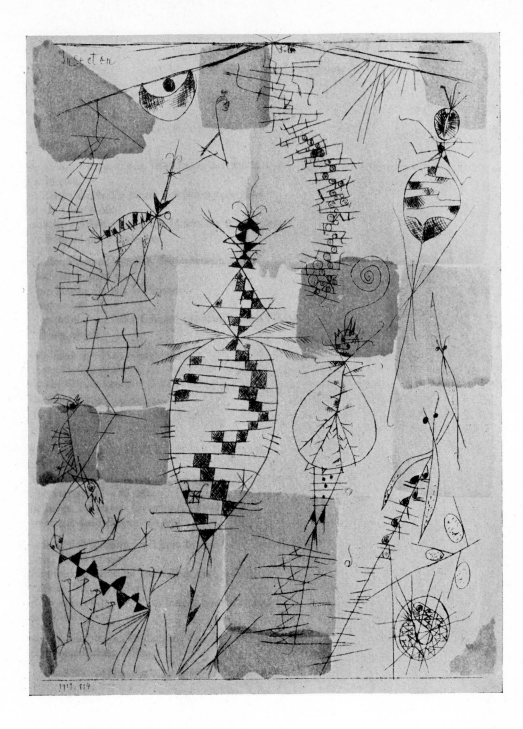

Insects. 1919. Lithograph with watercolor, 8 x 5¼″. Collection Mr. and Mrs. Lyonel Feininger.

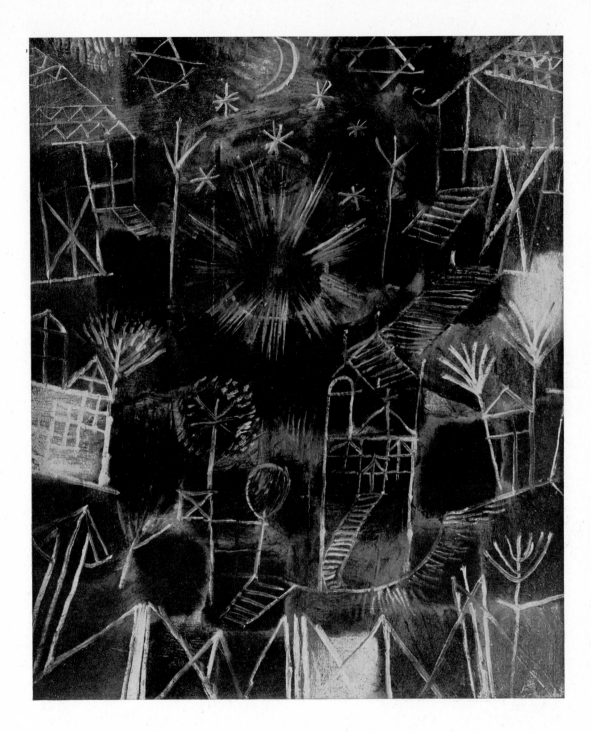

Cosmic Composition. 1919. Oil on wood, 18¾ x 16″. Collection Miss Helen R. Resor.

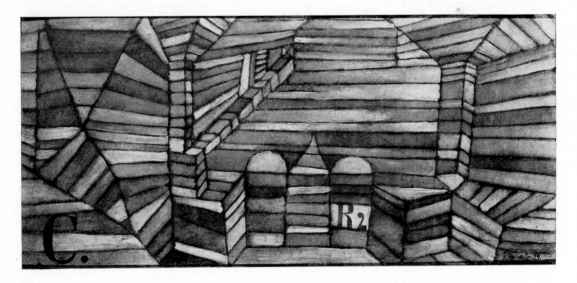

Arrival of the Circus. 1926. Oil on plaster, 6¾ x 10⅞". Collection Phillips Memorial Gallery.

Hall C. Entrance R 2. 1920. Oil on canvas, 9⅞ x 19¾". Collection Henry Church.

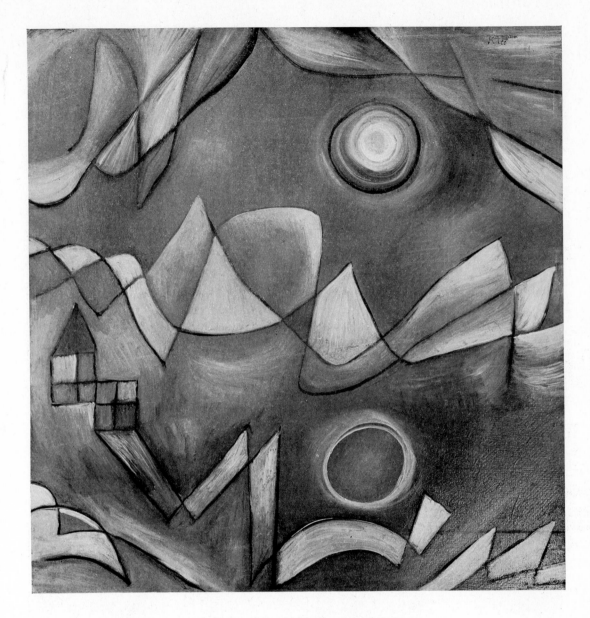

Arctic Thaw. 1920. Oil on cardboard, 20½ x 20″. Nierendorf Gallery.

opposite: The Holy One. 1921. Watercolor, 17½ x 12¼″. Collection Mme. Galka E. Scheyer.

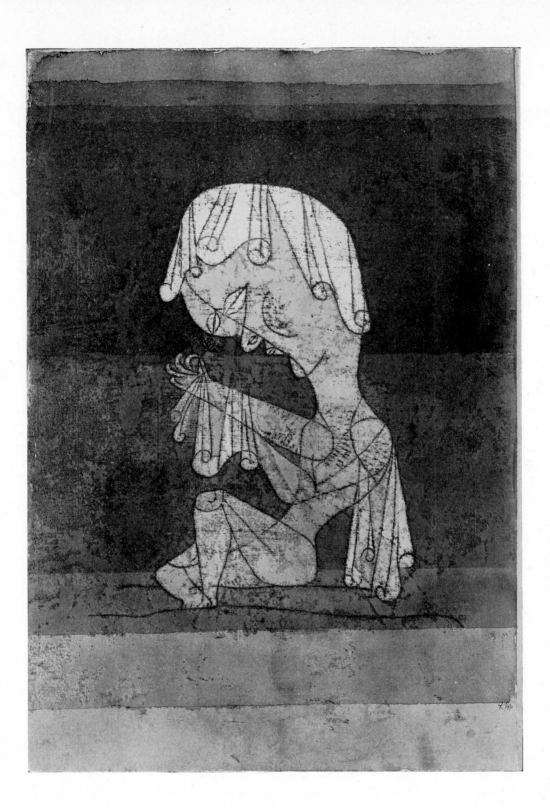

29

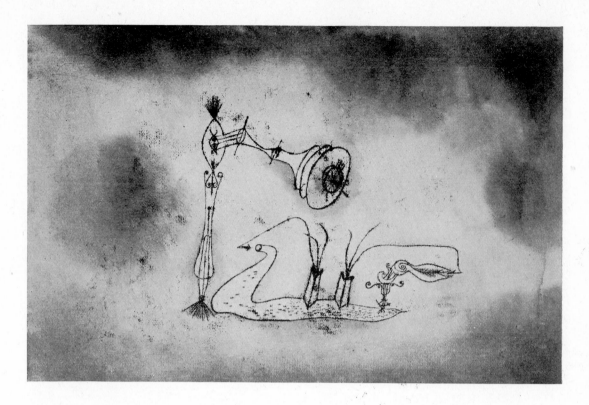

Apparatus for the Magnetic Treatment of Plants. 1921. Watercolor, 18⅞ x 12¼″. Germanic
Museum, Harvard University.

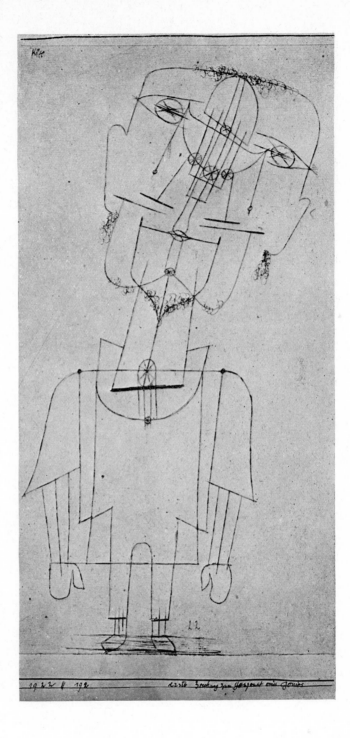

First drawing for the "Specter of a Genius." 1921. Pen
and ink. Collection Mme. Galka E. Scheyer.

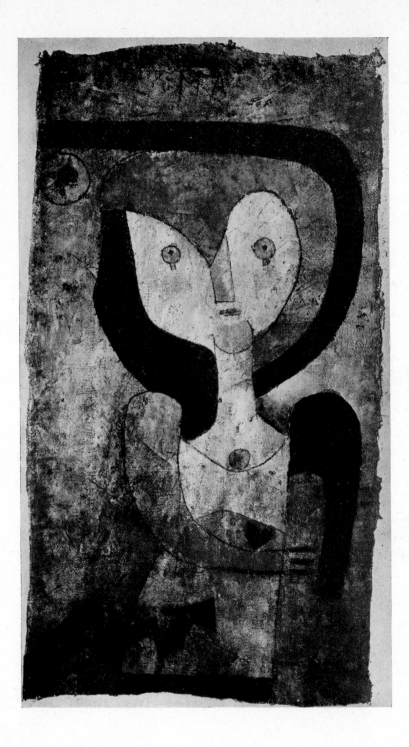

Ma. 1922. Mixed medium, 16 x 9″. Collection Bernard Koehler,
Berlin.

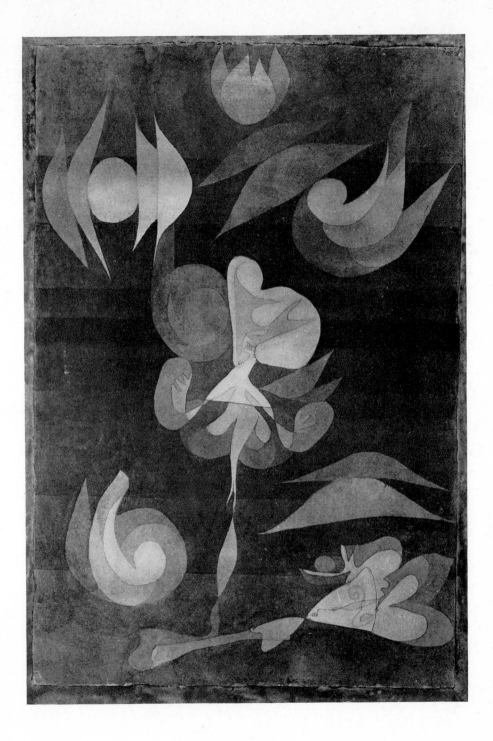

Dying Plants. 1922. Watercolor, 19 x 12¾". Collection Philip L. Goodwin.

Abstract Trio. 1923. Watercolor, 12⅞ x 19¾″. Private collection.

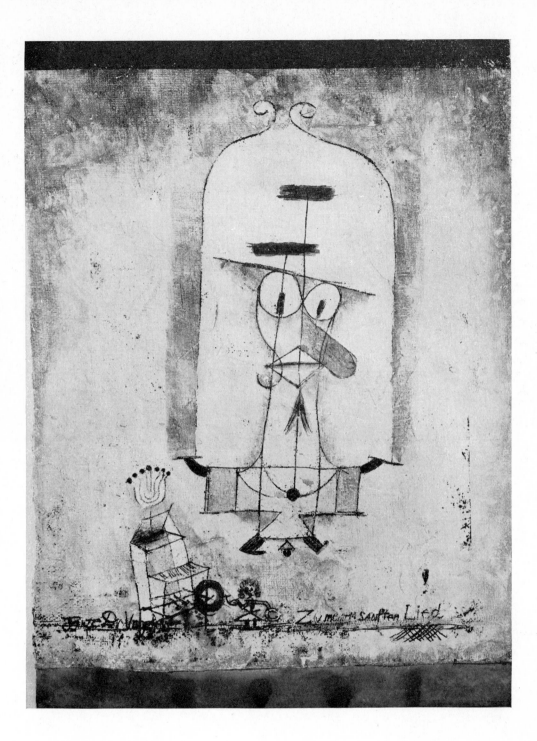

Dance You Monster to My Sweet Song. 1922. Oil, 15¾ x 11½". Solomon R. Guggenheim Foundation.

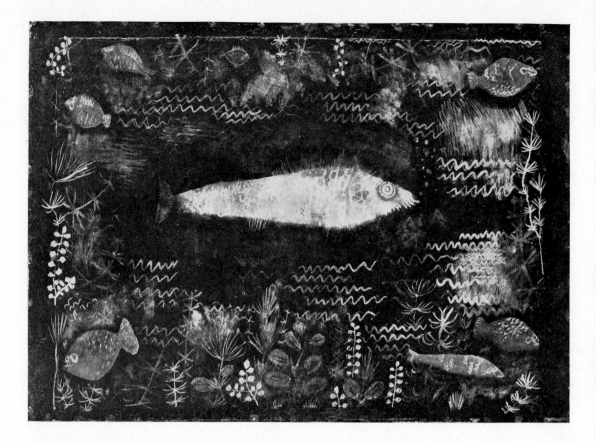

The Golden Fish. 1925–26. Oil. Private collection, Holland.

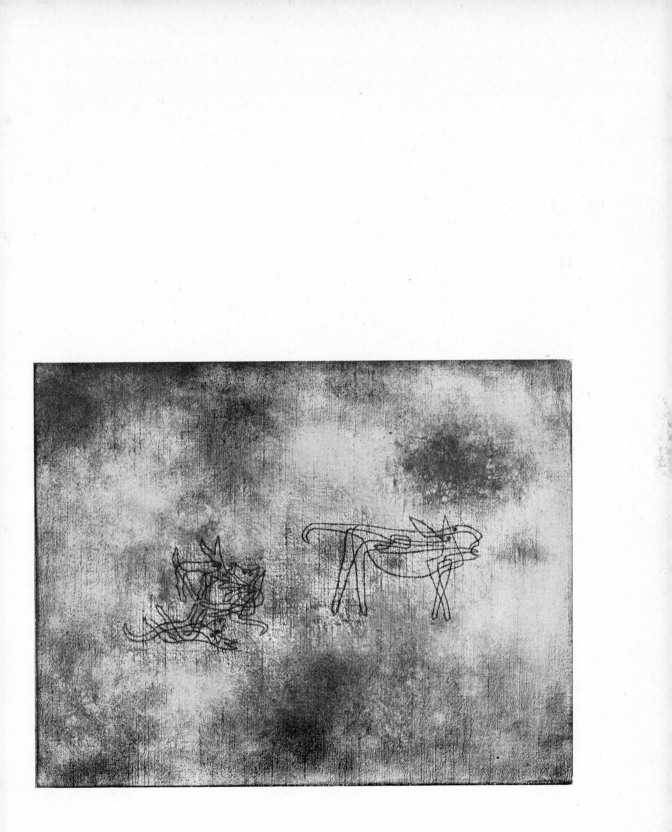

She Moos, We Play. 1928. Oil.

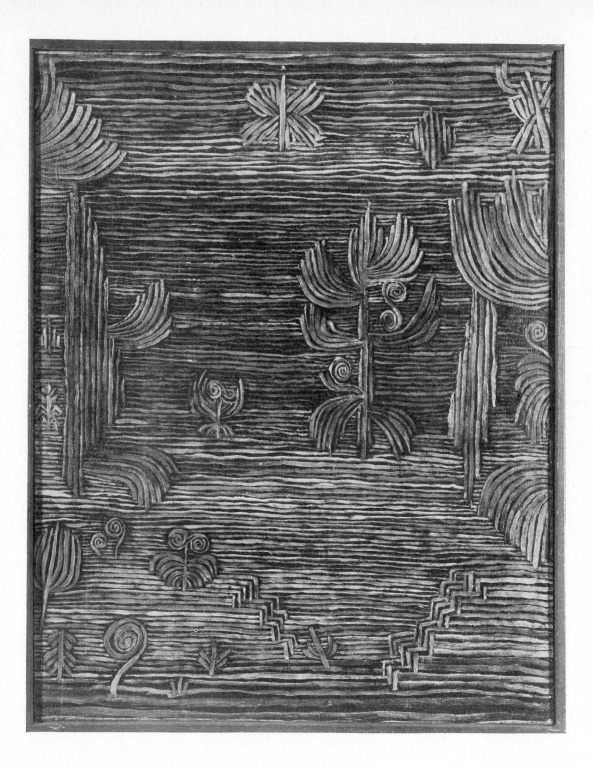

Exotic Garden. 1926. Oil on canvas, 23¼ x 19¼". Private collection.

38

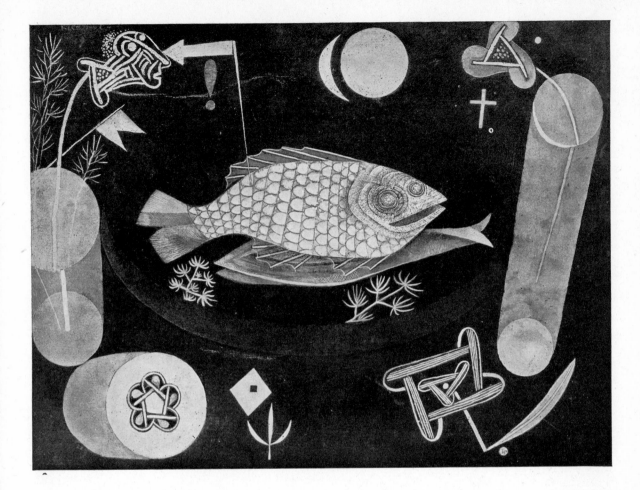

Around the Fish. 1926. Oil on canvas, 18⅜ x 25⅛″. The Museum of Modern Art. Mrs. John D. Rockefeller, Jr. Purchase Fund.

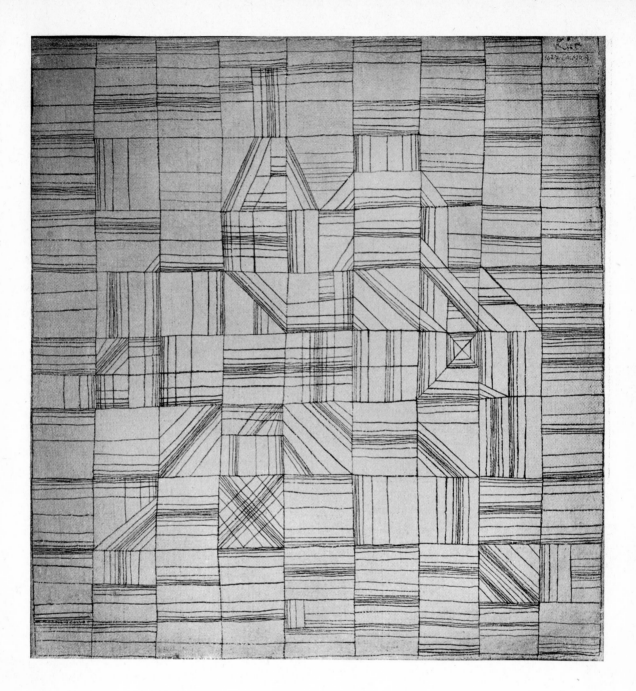

Variations. 1927. Oil on canvas, 16 x 15¾".

40

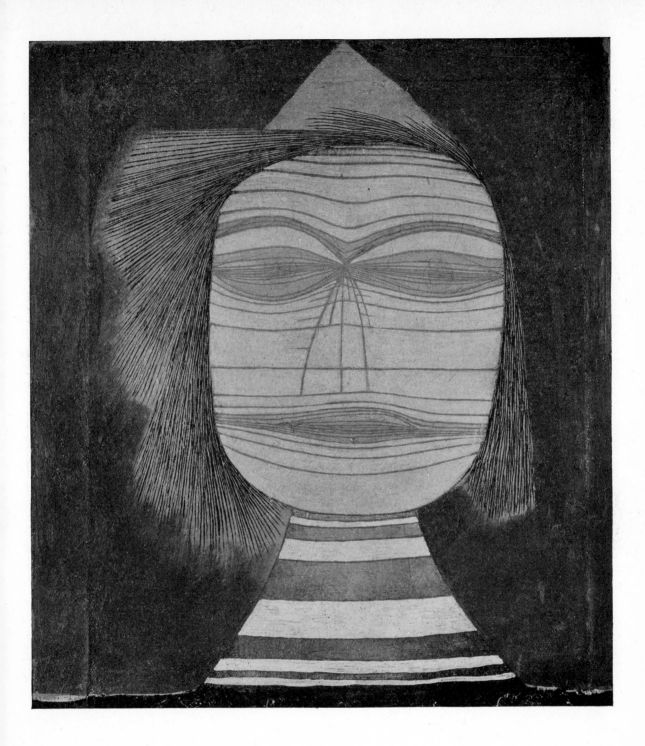

Actor's Mask. 1925. Oil on wood, 13¾ x 12½″. Collection Sidney Janis.

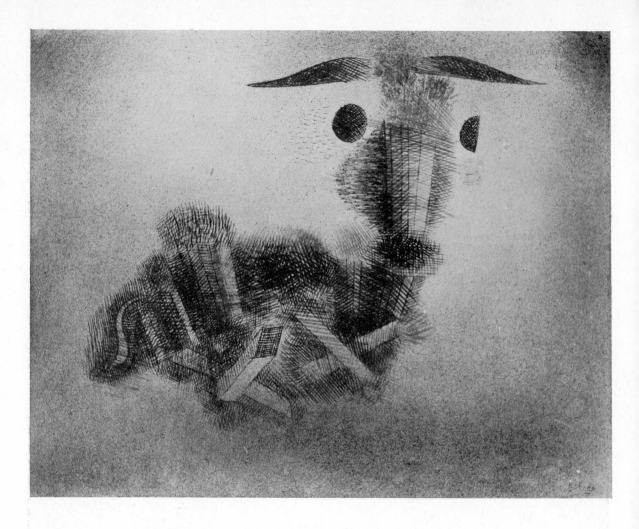

Goat. 1925. Watercolor, 8¾ x 11″. Collection Jere Abbott.

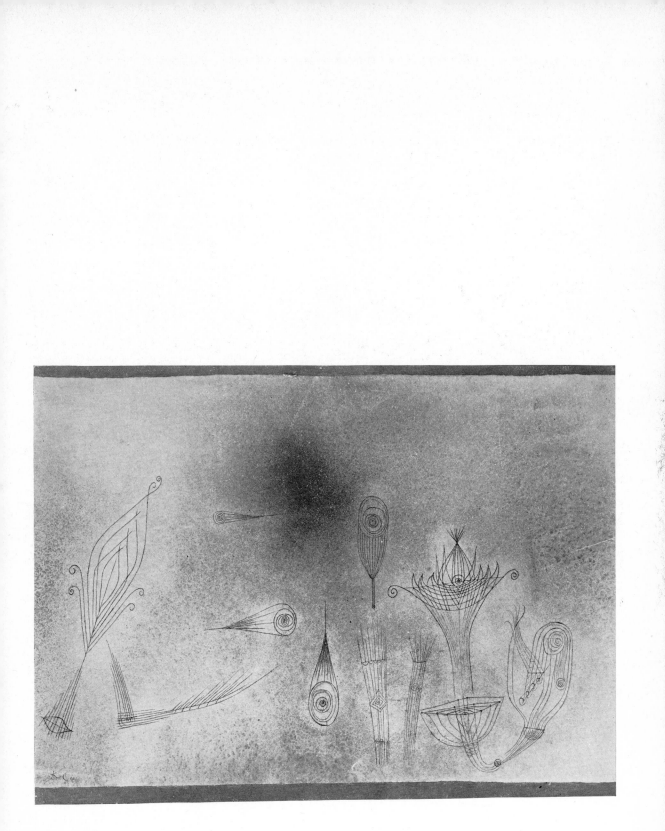

Plant Seeds. 1926. Ink and watercolor. Collection Mme. Galka E. Scheyer.

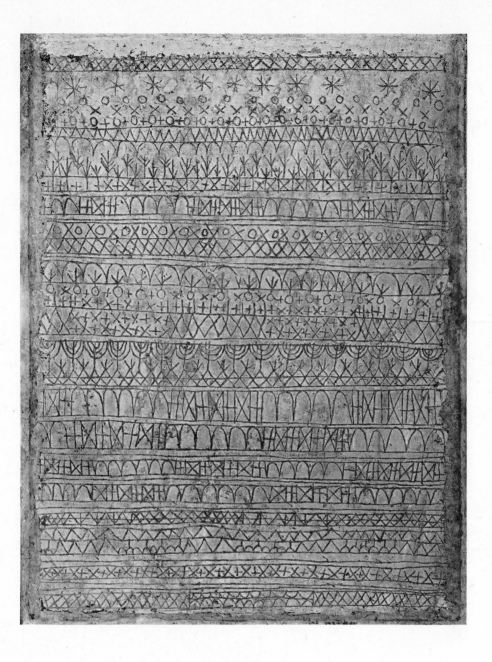

Pastorale. 1927. Oil on cardboard, 27¼ x 20¾″. The Museum of Modern Art.

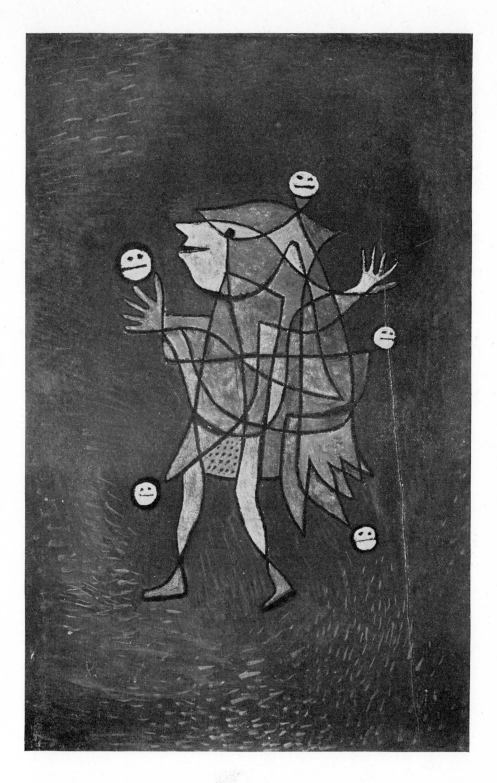

The Jester. 1928. Oil on canvas, 28½ x 18¾″. Private collection.

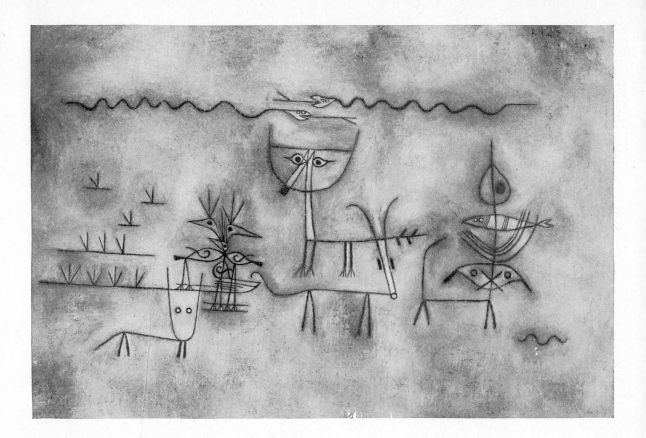

Zoo. 1928. Oil on wood, 19½ x 28". Collection M. Martin Janis.

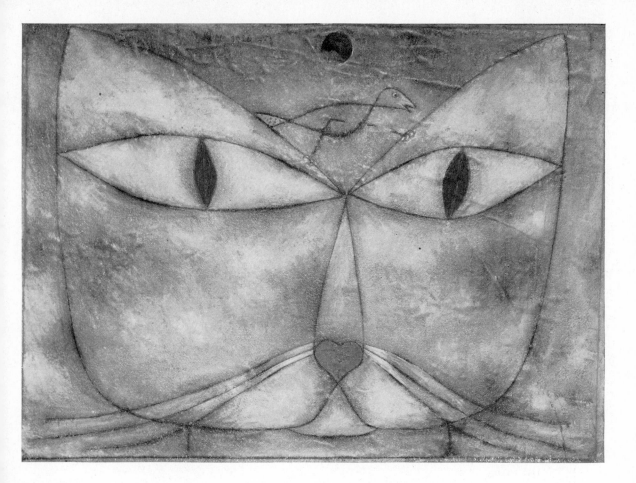

Cat and Bird. 1928. Oil on canvas, 15¼ x 21″. Collection Dr. F. H. Hirschland.

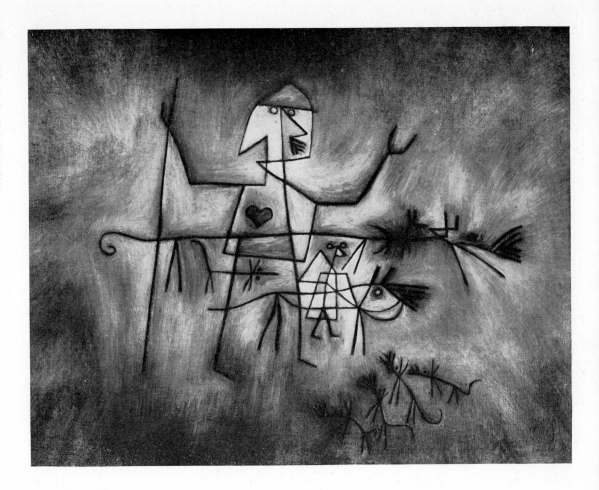

The Shepherd. 1929. Oil on wood, 19⅝ x 26¼". Collection Mr. and Mrs. Bernard J. Reis.

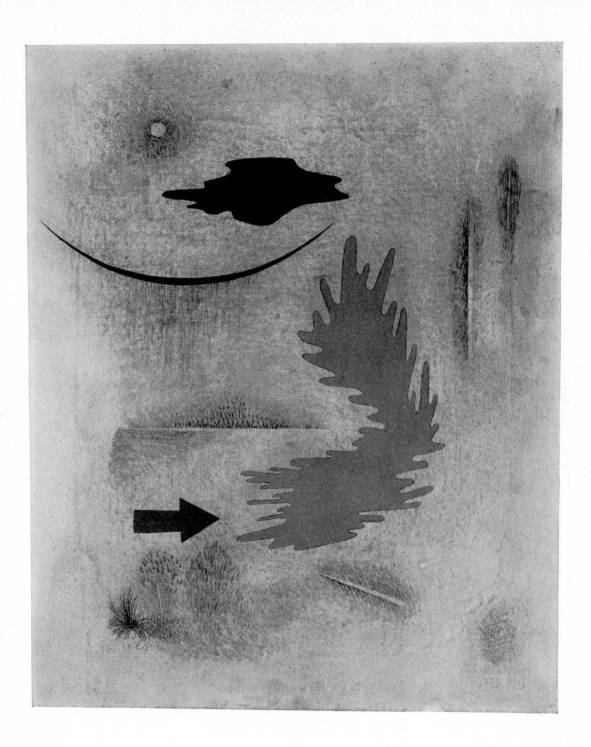

Mixed Weather. 1929. Mixed medium on canvas, 19½ x 16¼″. Nierendorf Gallery.

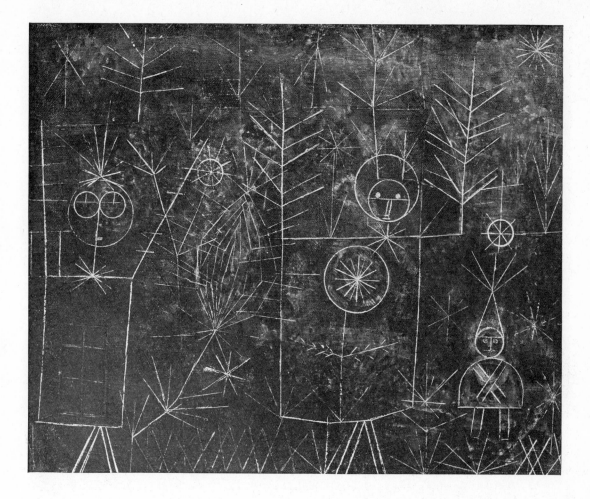

In the Grass. 1930. Oil on canvas, 16¾ x 20″. Collection Sidney Janis.

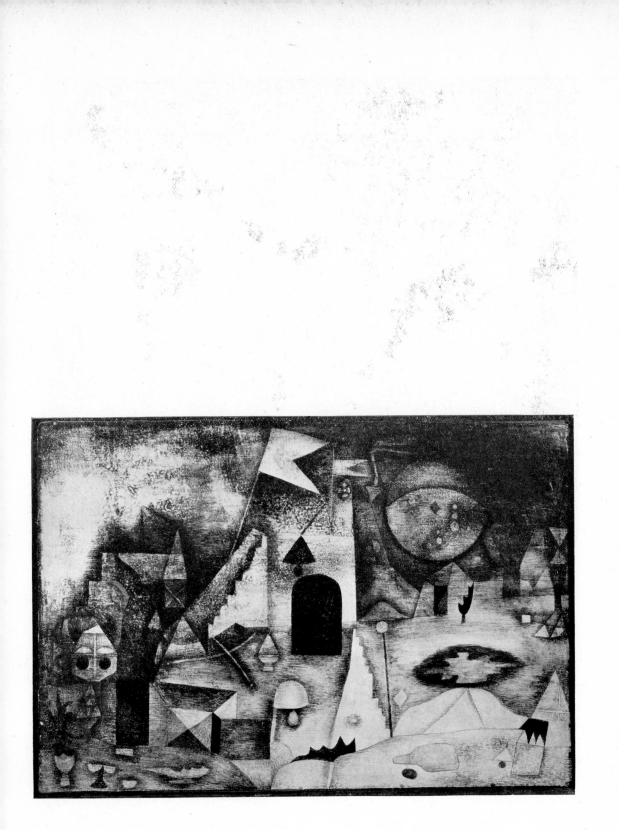

Romantic Park. 1930. Oil, 13 x 20″. Collection Mr. and Mrs. Edward M. M. Warburg.

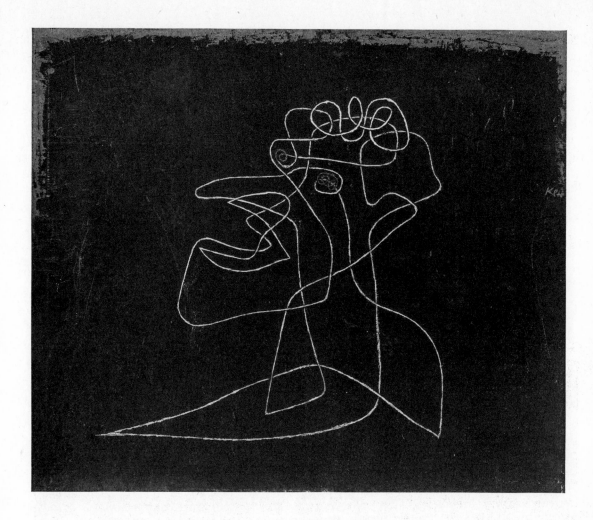

The Mocker Mocked. 1930. Oil on canvas, 17 x 20⅝″. The Museum of Modern Art. Gift of J. B. Neumann.

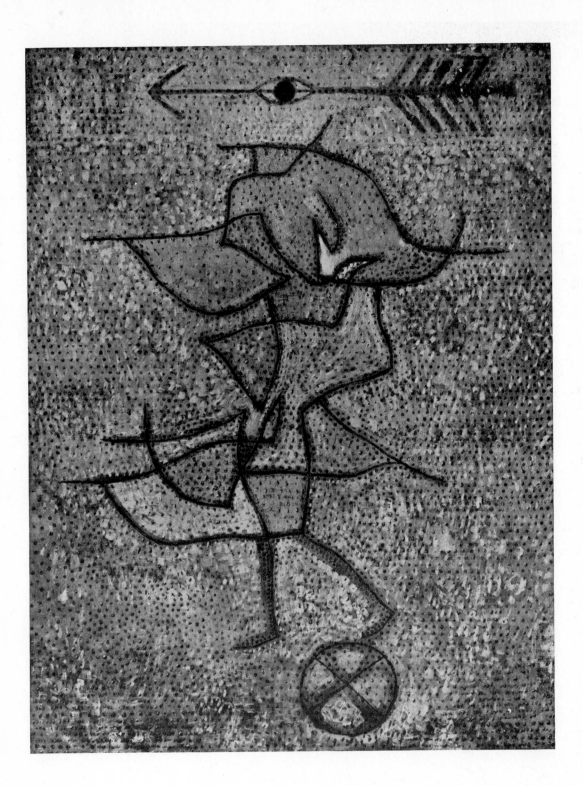

Diana. 1931. Oil on canvas, 31½ x 23¾". Collection Mr. and Mrs. Henry Clifford.

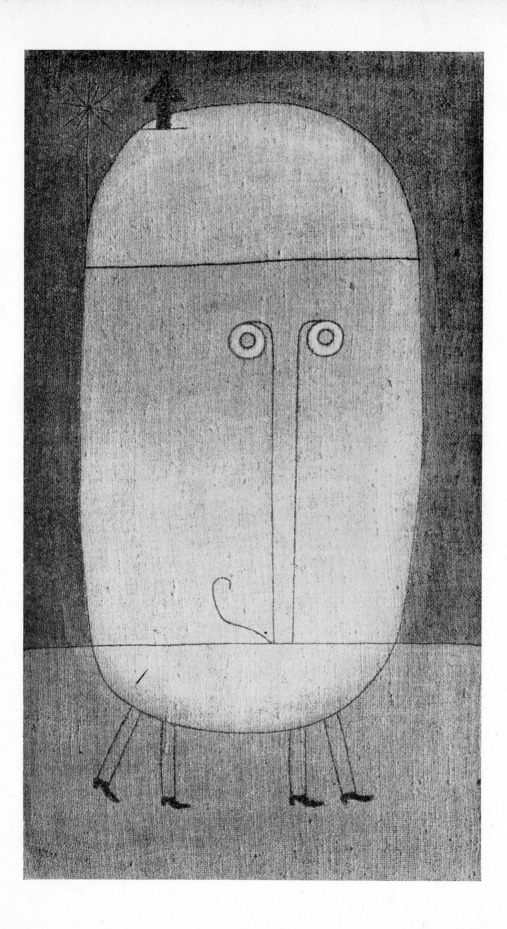

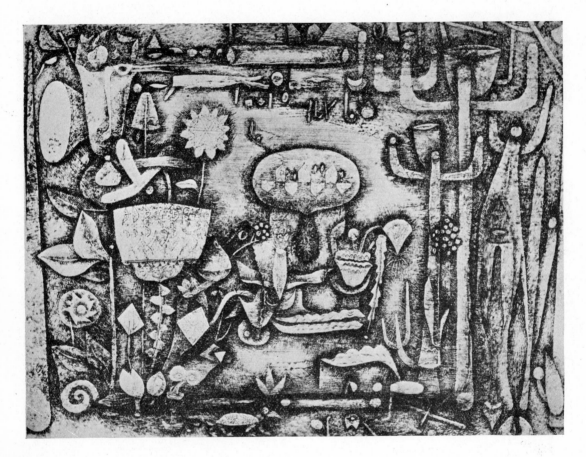

Botanical Garden. 1924–34. Oil.

opposite: Mask of Fear. 1932. Oil on burlap, 39½ x 22½″. Collection Dr. Allan Roos.

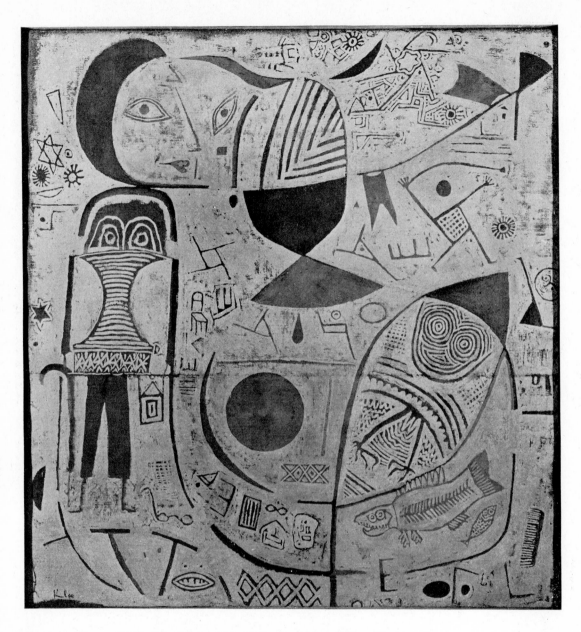

Picture Album. 1937. Oil, 23¼ x 22″. Collection Mrs. Julius Wadsworth.

opposite: One Who Understands. 1934. Oil on canvas, 21¼ x 16⅞″. Collection Leland Hayward.

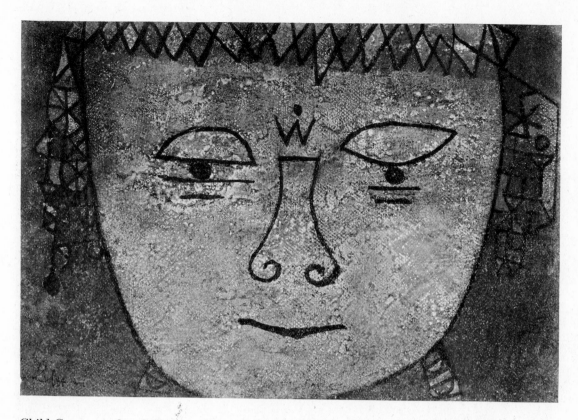

Child Consecrated to Suffering. 1935. Gouache, 6 x 9¼″. Albright Art Gallery, Buffalo.

opposite: Exotic. 1939. Oil on canvas, 27½ x 21″. Private collection.

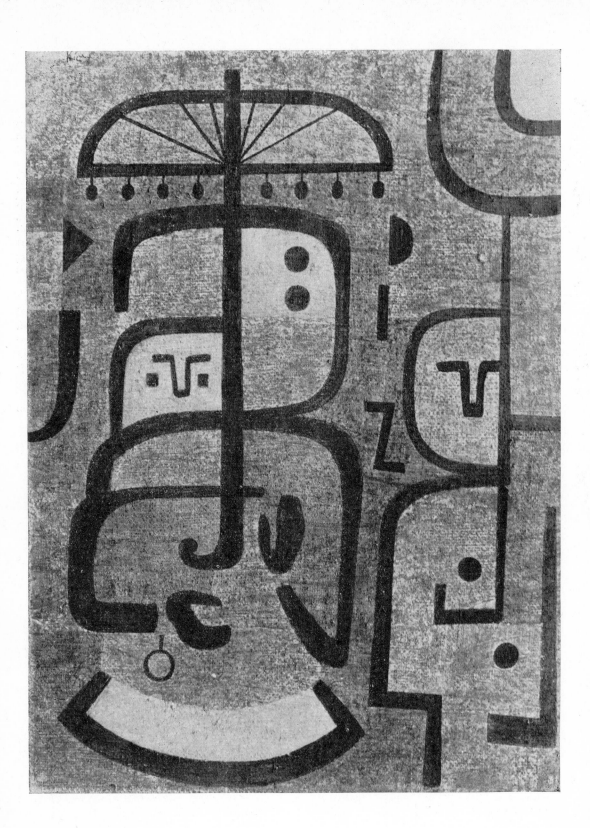

Bibliography

BROOKLYN, N. Y. Brooklyn Museum
1 drawing, 2 prints

BUFFALO, N. Y. Albright Art Gallery
1 gouache

CAMBRIDGE, MASS. Fogg Museum of Art
3 prints

CAMBRIDGE, MASS. Germanic Museum
2 watercolors

CHICAGO. Chicago Art Institute
1 watercolor, 1 print

DETROIT. Detroit Institute of Arts
1 drawing

HARTFORD, CONN. Wadsworth Atheneum
2 watercolors

MERION, PA. Barnes Foundation
2 watercolors

NEW HAVEN, CONN. Yale University,
Société Anonyme Collection
2 oils, 6 watercolors, 1 print

NEW YORK. Art of This Century
1 oil, 1 fresco, 4 watercolors, 3 gouaches

NEW YORK. Solomon R. Guggenheim Foundation
1 oil, 11 watercolors, 2 gouaches

NEW YORK. The Museum of Modern Art
3 oils, 3 watercolors, 2 gouaches, 33 prints, 3 postcards

OBERLIN COLLEGE, OHIO. Allen Memorial Art Museum
1 oil

PHILADELPHIA. Philadelphia Museum of Art,
Gallatin Collection, extended loan
1 watercolor, 1 gouache

ST. LOUIS. City Art Museum
1 watercolor, 1 print

SAN FRANCISCO. San Francisco Museum of Art
1 oil, 1 print

WASHINGTON, D. C. National Gallery of Art,
Lessing J. Rosenwald Collection
1 watercolor, 10 prints

WASHINGTON, D. C. Phillips Memorial Gallery
8 oils, 3 watercolors

Not included here are references to exhibition notes listed in Art Index, and to a few articles in German periodicals mentioned by Grohmann (see bibl. 49), and to some unillustrated exhibition catalogs.

The arrangement is alphabetical, under the author's name, or under the title in the case of unsigned articles. Publications of museums are entered under the name of the institution when that name is distinctive; otherwise, under the name of the city in which it is located. Exhibition catalogs issued by private galleries and art organizations are listed under the name of the gallery or group. All material except items preceded by † has been examined by the compiler.

ABBREVIATIONS Ag August, Ap April, Aufl Auflage, Bd Band, col colored, D December, ed editor, edited, F February, hft Heft, hrsg herausgegeben, il illustration(s), Ja January, Je June, Jy July, Mr March, My May, N November, no number, p page(s), por portrait(s), S September.

SAMPLE ENTRY for magazine article. BILL, MAX. Paul Klee. 16il Das Werk 27:209–16 Ap 1940.

EXPLANATION. An article by Max Bill, entitled "Paul Klee," containing 16 illustrations will be found in Das Werk, volume 27, pages 209 to 216 inclusive, the April, 1940 issue.

* Items so marked are in the Museum Library.

HANNAH B. MULLER

Writings by Klee

† 1 AUFSÄTZE. Die Alpen (Berne) 6 1912.
Exhibition review.

1a EXAKTE VERSUCHE IM BEREICH DER KUNST. Bauhaus; Zeitschrift für Gestaltung 2no2-3:17 1928.
Reprinted with 1il and por in Bauhaus prospectus 1929, and in bibl. 36a.

* 2 PÄDAGOGISCHES SKIZZENBUCH. 2. Aufl. 51p 87il München, Langen, 1925. (Bauhausbücher 2)
* English translation by Sibyl Peech. 67p 87il New York, Nierendorf Gallery, 1944.

3 SCHÖPFERISCHE KONFESSION. p28-40 Berlin, E. Reiss, 1920. (Tribüne der Kunst und Zeit . . . hrsg. von Kasimir Edschmid, XIII)

* 4 WEGE DES NATURSTUDIUMS. *In* Staatliches Bauhaus in Weimar, 1919-1923. p24-5 1il Weimar-München, Bauhausverlag, 1923.

For partial reprint of bibl.3 *see* p10–13 of this volume.

SEE ALSO bibl. 35, 36a, 48, 70, 86, 104.

Books Illustrated by Klee

† 4a CORRINTH, C. Potsdamer Platz, oder die Nächte der neuen Messias. München, G. Müller, 1920. (Bücher der Zeit)
Contains 10 lithographs by Klee.

† 5 DÄUBLER, THEODOR. Mit silberner Sichel. Mit Radierungen von Paul Klee. Berlin, Fritz Gurlitt Verlag. (Neue Bilderbücher IV. Reihe)
This was announced in Das graphische Jahr Fritz Gurlitt for 1921. Its actual publication has not been ascertained.

* 6 VOLTAIRE, FRANÇOIS MARIE AROUET DE. Candide, with . . . illustrations by Paul Klee. 120p 26il New York, Pantheon Books, 1944.
The drawings, done in 1911, were first published with German text by Kurt Wolff-Verlag, Munich, 1920.

Literature on Klee

ARAGON, LOUIS. See 32, 45.

DER ARARAT, See 57, 68, 80, 82.

* 7 ART STUDENTS LEAGUE OF NEW YORK. Paul Klee. 7p 4il 1941.
Exhibition catalog with introduction by Clark Mills.

ARTLOVER. See 79.

* 8 ARTS CLUB OF CHICAGO. Paul Klee: memorial exhibition. 8p 1il 1941.
Exhibition catalog with essay by James J. Sweeney reprinted from Buchholz Gallery catalog, 1940. 64 of the 83 works listed were the same as those circulated by the Museum of Modern Art, 1940.

9 BALLAŸ ET CARRÉ, PARIS. Paul Klee: tableaux et aquarelles de 1917 à 1937. folded sheet 6il 1938.
Exhibition catalog.

BARR, ALFRED H., JR. See 71-2, 74-5.

† 10 BAUHAUS; Zeitschrift für Gestaltung. 9p 14il D 1931.
Number dedicated to Klee. Articles by Kandinsky, Grohmann, Hertel.

———— See also 1a.

11 BAYNES, H. G. Mythology of the soul: a research into the unconscious from schizophrenic dreams and drawings. p515, 563, 607-9, 678-9 3il Baltimore, Williams & Wilkins co., 1940.

12 BEHNE, ADOLF. Paul Klee. Die Weissen Blätter 4no 5:167-9 My 1917.

13 BERNE. KUNSTHALLE. Gedächtnisausstellung Paul Klee. 16p 10il 1940.
Exhibition catalog.

14 ———— Paul Klee. 15p 8il 1935.
Exhibition catalog.

* 15 BERNHEIM, GEORGES, GALERIE, PARIS. Exposition Paul Klee. 7p 2il 1929.
Exhibition catalog with introduction by René Crevel. Crevel's text, translated into German, appears with 2il in Querschnitt 8hft4:253-4 Ap 1928. An excerpt also
* appears in catalog published by Kestner-Gesellschaft, 1931 (bibl.54) and in Grohmann's Paul Klee (bibl.45)

* 16 BERNOULLI, RUDOLF. Mein Weg zu Klee. Randbemerkungen zu einer Ausstellung seines graphischen Werkes in der Eidg. Graphischen Sammlung in Zürich 1940. 27p 8il Bern, Verlag Benteli, 1940.

BIENERT, IDA, COLLECTION. See 46.

* 17 BILL, MAX. Paul Klee. 16il Das Werk 27:209-16 Ap 1940.

* 18 BLOESCH, HANS & SCHMIDT, GEORG. Paul Klee, Reden zu seinem Todestag 29. Juni 1940. 18p 5il(2por) Bern, Verlag Benteli, 1940.

* 19 BUCHHOLZ GALLERY, NEW YORK. Paul Klee, March 23rd to April 23rd. 4p 1il [1938]
Exhibition catalog.

* 20 ———— Paul Klee, November 1-26. 3p [1938]
Exhibition catalog.

* 21 ———— & WILLARD GALLERY, NEW YORK. Paul Klee. 32p 27il 1940.
Exhibition catalog with essays by James J. Sweeney, Julia and Lyonel Feininger, and a bibliography.

* 22 BULLIET, CLARENCE JOSEPH. The significant moderns and their pictures. p172-4 4il New York, Covici-Friede, 1936.

* 23 CHENEY, SHELDON. The story of modern art. passim New York, Viking Press, 1941.

* 24 CINCINNATI MODERN ART SOCIETY. Paintings by Paul Klee . . . exhibited at the Cincinnati Art Museum. p3-7, 11-13 3il(1por) 1942.

* 25 CONTEMPORA ART CIRCLE, NEW YORK. Paul Klee at Neumann's. 4p 1935.
Note on Klee by J. B. Neumann.

* 26 COSSIO DEL POMAR, FELIPE. Nuevo arte. p201-2 Buenos Aires, "La Facultad," 1934.

COURTHION, PIERRE. See 99.

* 27 CREVEL, RENÉ. Paul Klee. 63p 37il(1por) Paris, Gallimard, 1930. (Peintres nouveaux)
Biographical note, p13-16, is, for the most part, a translation of information given in Der Ararat (bibl.68)

——— See also 15, 45, 54.

28 DÄUBLER, THEODOR. Paul Klee. 1il Das Kunstblatt 2:24-7 Ja 1918.

* 29 DÜSSELDORF. KUNSTVEREIN FÜR DIE RHEINLANDE UND WESTFALEN. Paul Klee. 29p 1931.
Exhibition catalog with introduction by Will Grohmann. Organized in cooperation with Galerie Flechtheim.

* 30 EINSTEIN, CARL. Die Kunst des 20. Jahrhunderts. 2. Aufl. p153-7 8il(1col) Berlin, Propyläen-Verlag, 1926. (Propyläen Kunstgeschichte XVI)

ELUARD, PAUL. See 45, 47. (French and English versions of the same poem.)

FEININGER, LYONEL AND JULIA. See 21, 47, 75.

* 31 FLECHTHEIM, ALFRED, GALERIE, BERLIN. Paul Klee. 18p 17il 1929.
Exhibition catalog.

* 32 ——— Paul Klee. 8p 5il 1930.
Exhibition catalog. Introduction by Louis Aragon (reprinted from Grohmann's Paul Klee) p4.

* 33 ——— Paul Klee, neue Bilder und Aquarelle. 3p 1il 1931.
Exhibition catalog.

——— See also 29.

* 34 FROST, ROSAMUND. Klee: pigeons come home to roost. 6il Art News 41:24-5 Je 1942.

* 35 GARVENS, GALERIE VON, HANNOVER. Paul Klee, Gemälde, Zeichnungen, Graphik aus den Jahren 1903-1921. 4p 2il 1921.
Exhibition catalog with excerpts from Klee's Journal and Hausenstein's Kairuan.

* 36 GOLDWATER, ROBERT J. Primitivism in modern painting. p153-61 3il New York, Harper, 1938.

* 36a ——— & TREVES, MARCO. Artists on art. p441-4 New York, Pantheon Books, 1945.
Includes quotations from Klee's Journal and Bauhaus prospectus 1929 (bibl. 1a).

GOLTZ, HANS, GALERIE, MUNICH. See 68.

* 37 GREENBERG, CLEMENT. On Paul Klee (1879-1940) Partisan Review 8no3:224-9 My-Je 1941.

* 38 GRIGSON, GEOFFREY. The arts to-day. p90-2 1il London, John Lane, 1935.

39 ——— Paul Klee. 1il The Bookman (London) 85:390-1 Ja 1934.
Exhibition, Mayor Gallery.

* 40 GROHMANN, WILL. L'art contemporain en Allemagne. 3il Cahiers d'Art 13no1-2:9 1938.

* 41 ——— The drawings of Paul Klee. 20p 73il New York, Curt Valentin, 1944.
* A reissue of the plates and a translation, by Mimi Catlin and Margit von Ternes, of the text of Handzeichnungen, 1921-1930. 30p 74il Potsdam, Berlin, Müller & I. Kiepenheuer, 1934. The German version contains a definitive catalog not reprinted in the 1944 edition.

* 42 ——— Klee at Berne. 1il Axis no2:12-13 Ap 1935.
Exhibition, Kunsthalle, Berne.

* 43 ——— Paul Klee 1923-24. 15il(1col) Der Cicerone 16hft17:786-98 Ag 1924.
* Reprinted in Jahrbuch der Jungen Kunst 1924:143-51.

* 44 ——— Paul Klee. 15il Cahiers d'Art 3no7:295-302 1928.

* 45 ——— Paul Klee. 27p 91il Paris, Éditions "Cahiers d'Art," 1929.
Includes "Hommages à Paul Klee" by Louis Aragon, René Crevel, Paul Eluard, Jean Lurçat, Philippe Soupault, Tristan Tzara, Roger Vitrac.

* 46 ——— Die Sammlung Ida Bienert. p14-15,21 16il Potsdam, Müller & I. Kiepenheuer, 1933. (Privatsammlungen neuer Kunst, Bd 1)

——— See also 10, 29, 49.

* 47 GUGGENHEIM, PEGGY, ed. Art of this century. p47-50 2il New York, Art of This Century, 1942.
Includes "Paul Klee, 1924," poem by Paul Eluard, and excerpt from essay by Julia and Lyonel Feininger (bibl.21).

* 48 HAUSENSTEIN, WILHELM. Kairuan, oder eine Geschichte vom Maler Klee und von der Kunst dieses Zeitalters. 134p 43il (some col) München, Kurt Wolff Verlag, 1921.
Includes quotations from Klee's Journal.

† 48a HIRSCH, KARL JAKOB. The painter, Paul Klee. 8il por Musaion (Prague) 1929-30:208.
Exhibition, Galerie Flechtheim, Berlin. Text in Czech.

* 49 HUYGHE, RENÉ. Histoire de l'art contemporain; la peinture. passim 2il Paris, Alcan, 1935.
Biographical and bibliographical note by Will Grohmann, p439, reprinted from Amour de l'Art 15:435-7,439 S 1934, 2il.

* 49a JANSON, H. W. [Review of] Paul Klee, *Pedagogical sketch book* [and] Will Grohmann, *The drawings of Paul Klee*. College Art Journal 4no4:232-5 My 1945.

50 JOLLOS, WALDEMAR. Paul Klee. 7il Das Kunstblatt 3:225-34 Ag 1919.

* 51 JUSTI, LUDWIG. Von Corinth bis Klee. p193-7 3il Berlin, Bard, 1931.

† 52 KAISER, HANS. [Paul Klee] Hohe Ufer (Hannover) 2:14 1920.

* 53 KALLEN, HORACE M. Art and freedom. 2:728-9 New York, Duell, Sloan and Pearce, 1942.

KANDINSKY, WASSILY. See 10.

* 54 KESTNER-GESELLSCHAFT, HANNOVER. Paul Klee. 6p 3il 1931.
 Exhibition catalog with excerpt from René Crevel's Merci Paul Klee, published in catalog issued by Galerie Georges Bernheim, 1929 (bibl.15) and in Querschnitt 8hft4:253-4 Ap 1928.

55 KLEIN, JEROME. Line of introversion. New Freeman 1:88-9 1930.

* 56 KLUMPP, HERMANN. Abstraktion in der Malerei: Kandinsky, Feininger, Klee. passim 6il Berlin, Deutscher Kunstverlag, 1932. (Kunstwissenschaftliche Studien, Bd XII)

* 57 KOLLE, HELMUD. Paul Klee. 1il Der Ararat 2:112-14 1921.
 Criticism of article on Paul Klee by Hans Kaiser in Hohe Ufer 2:14 1920.

58 ——— Über Klee, den Spieltrieb und das Bauhaus. 1il Das Kunstblatt 6:200-5 My 1922.

* 59 LEICESTER GALLERIES, LONDON. Catalogue of an exhibition of paintings and watercolors by Paul Klee. 12p 4il 1941.
 Introduction by Herbert Read.

60 LHOTE, ANDRÉ. L'exposition Klee. Nouvelle Revue Française 26:247-9 F 1926.

* 61 LIMBOUR, GEORGES. Paul Klee. 1il Documents 1:53-4 Ap 1929.

* 62 LURÇAT, JEAN. Hommage à Paul Klee. 2il Omnibus (Berlin) p55-7 1932.
 Reprinted from Grohmann's Paul Klee (bibl.45).

* 63 McCAUSLAND, ELIZABETH. Paul Klee's paintings in memorial showing. 2il Springfield Sunday Union and Republican (Mass.) p6E Jy 13 1941.

* 64 MARLIER, GEORGES. Paul Klee. 2il Cahiers de Belgique 2:76-8 F 1929.
 Exhibition, Galerie Le Centaure.

* 65 MICHEL, WILHELM. Paul Klee. In Das Graphische Jahrbuch, hrsg. von Hans T. Joel. p48 Darmstadt, Karl Lang [1919?]

MILLS, CLARK. See 7.

66 MILO, JEAN. Paul Klee. 1il Cahiers de Belgique 1:196-8 1928.

MONGAN, ELIZABETH. See 83.

MORLEY, GRACE L. McCANN. See 86.

* 67 NEUE KUNST FIDES, GALERIE, DRESDEN. Paul Klee. 12p 6il 1929.
 Exhibition catalog with introduction by Rudolf Probst.

68 NEUE KUNST-HANS GOLTZ, GALERIE, MUNICH. Paul Klee: Katalog der 60. Ausstellung der Galerie. 31il Der Ararat, Sonderheft 2:1-25 1920.
 Includes biographical sketch based on information supplied by the artist (translated into French in bibl.27) and a listing of 356 of his drawings, prints, paintings, and sculptures.

NEUMANN, J. B. See 25, 79.

* 69 NEUMANN-WILLARD GALLERY, NEW YORK. Paul Klee. 2p 1939.
 Exhibition catalog.

* 70 NEW YORK. MUSEUM OF MODERN ART. Bauhaus, 1919-1928. passim 10il 1938.
 Statement by Klee, p172, partial translation of bibl.1a.

* 71 ——— Fantastic art, dada, surrealism [ed. by Alfred H. Barr, Jr.] p215-16 6il 1936.

* 72 ——— German painting and sculpture [ed. by Alfred H. Barr, Jr.] p26-7 2il 1931.

* 73 ——— Modern drawings, ed. by Monroe Wheeler. p40-1,90 3il 1944.

* 74 ——— Paul Klee [ed. by Alfred H. Barr, Jr.] 17p 11il 1930.
 Introduction by Alfred H. Barr, Jr., reprinted in Omnibus (Berlin) p206-9 4il 1931 and, with revisions, in bibl.75.

* 75 ——— Paul Klee, articles by Alfred H. Barr, Jr., James Johnson Sweeney, Julia and Lyonel Feininger. 12p 26il(1por) 1941.
 Catalog of exhibition circulated by the Museum of Modern Art. Article by Barr reprinted from bibl.74; articles by Sweeney and Feininger reprinted from bibl.21.

* 76 NIERENDORF, KARL, ed. Paul Klee, paintings, watercolors, 1913 to 1939; introduction by James Johnson Sweeney. 35p 68il(2col, 1por) New York, Oxford University Press, 1941.
 Includes bibliography.

* 77 NIERENDORF GALLERIES, NEW YORK. Exhibition Paul Klee. 7p 1il 1938.
 Exhibition catalog with introduction by Perry Rathbone.

* 78 ——— Works by Klee. 4p 3il 1945.
 Exhibition catalog.

79 PAUL KLEE. 5il Artlover, ed. by J. B. Neumann 3no1:3-7 1936.

80 [PAUL KLEE] Der Ararat 1:123 1920.

† 81 PAUL KLEE. Berlin, 1918 (Sturm Bilderbücher III)

82 Paul Klee und die Kritik. Der Ararat 1no8:80 Jy 1920.
Excerpts from critical articles on Klee exhibition, 1920.

* 82a Pearson, Ralph M. Experiencing American pictures. p33-6 1il New York, Harper, 1943.

* 83 Philadelphia Art Alliance. Paul Klee: paintings, drawings, prints. 15p 3il 1944.
Text by Elizabeth Mongan and James J. Sweeney.

* 84 Phillips Memorial Gallery, Washington, D. C. Paul Klee: a memorial exhibition. 4p 1942.
Text by Duncan Phillips.

Probst, Rudolf. See 67.

Rathbone, Perry. See 77.

* 85 Read, Herbert. Art now. p140-3 New York, Harcourt, Brace, 1934.

———— See also 59, 99.

* 85a Rosengart, Galerie, Lucerne. Paul Klee, zum gedächtnis. 13p 9il 1945.
Exhibition catalog with text by Georg Schmidt.

* 86 San Francisco Museum of Art. Paul Klee memorial exhibition: addenda to the exhibition of the Museum of Modern Art. 8p 3il 1941.
Exhibition catalog with introduction by Grace Morley and excerpts from Klee's letters.

* 87 Schardt, Alois J. Das Übersinnliche bei Paul Klee. 3il Museum der Gegenwart 1:36-46 1930.

*88 ———— Paul Klee. 6il California Arts & Architecture 58:20-1,40 Je 1941.

* 89 Scheffler, Karl. Paul Klee: Ausstellung in der Galerie Alfred Flechtheim. 4il Kunst und Künstler 28:112-14 D 1929.

90 Scheewe, L. Klee. In Thieme-Becker. Allgemeines Lexikon der bildenden Künstler 20:424-6 1927.
Includes bibliography.

* 91 Schiess, Hans. Notes sur Klee à propos de son exposition à la Galerie Simon. 8il Cahiers d'Art 9no5-8:178-84 1934.

Schmidt, Georg. See 18, 85a.

* 92 Schwetzov, Hyman. Poems to two paintings by Paul Klee: The school girl; Actor's mask. Accent 5no2:95-6 Winter 1945.

* 93 Seize, Marc. Paul Klee. 2il Art d'Aujourd'hui 6no22:18 Summer 1929.

* 93a Soby, James Thrall. The prints of Paul Klee. 40il (8col) New York, Curt Valentin, 1945.

Soupault, Philippe. See 45.

94 Der Sturm. See issues from 1913 to 1923 for frequent reproductions of works by Klee. (References to these appear in bibl. 90.)

Sweeney, James Johnson. See 8, 21, 75, 76, 83.

* 95 Sydow, Eckart von. Die deutsche expressionistische Kultur und Malerei. p124-6 1il Berlin, Furche-Verlag, 1920.

* 96 Tériade, E. Documentaire sur la jeune peinture. 4il Cahiers d'Art 5no2:69-84 1930.

Thieme-Becker. See 90.

* 97 Thwaites, John A. Paul Klee and the object. 8il Parnassus 9no6:9-11; no7:7-9, 33-4 N-D 1937.

* 98 Todd, Ruthven. Paul Klee. London Bulletin no12:18 Mr 1939.
A poem.

Tzara, Tristan. See 45.

* 99 XXe Siècle. 11il no4:30-6 D 1938.
"Homage to Paul Klee" with articles by Herbert Read and Pierre Courthion.

* 100 Vitrac, Roger. A propos des oeuvres récentes de Paul Klee. 10il Cahiers d'Art 5:300-6 1930.

———— See also 45.

* 101 Wedderkop, H. von. Paul Klee. 16p 33il Leipzig, Klinkhardt & Biermann, 1920. (Junge Kunst, Bd 13)
* Major portion of text and plates reprinted in Cicerone 12hft14:527-38 Jy 1920 and in Jahrbuch der Jungen Kunst 1920:225-36.

* 102 Westheim, Paul. Helden und Abenteurer: Welt und Leben der Künstler. p224-7 1il Berlin, Reckendorf, 1931.

Wheeler, Monroe. See 73.

Willard Gallery, New York. See 21, 69.

* 103 Willrich, Wolfgang. Säuberung des Kunsttempels: eine kunstpolitische Kampfschrift zur Gesundung deutscher Kunst im Geiste nordischer Art. passim 2il Munchen, Berlin, Lehmanns Verlag, 1937.

104 Zahn, Leopold. Paul Klee: Leben, Werk, Geist. 87p 69il Potsdam, Kiepenheuer, 1920.
Includes excerpts from Klee's Journal, 1902-1905, p26-9, and facsimile of his handwriting.

* 105 Zervos, Christian. Histoire de l'art contemporain. p393-406 18il Paris, Éditions Cahiers d'Art, 1938.

* 106 Zurich. Kunsthaus. Klee. 24p 12il 1940.
Exhibition catalog.

164